IN & AROUND WINCHCOMBE

THROUGH TIME

David Aldred & Tim Curr

D1295516

AMBERLEY PUBLISHING

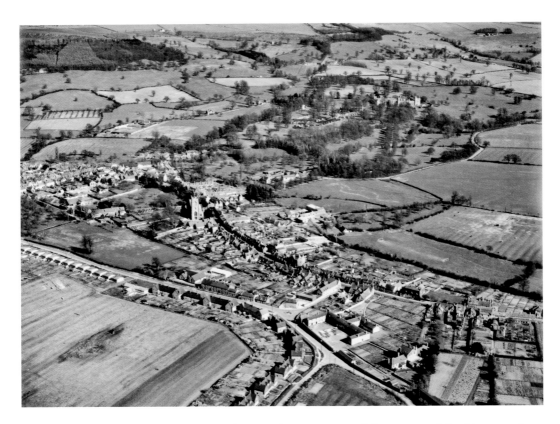

Winchcombe from the Air looking North-East. This 1951 view of the town is full of interest, from the Victorian workhouse and temporary post-war housing along Back Lane in the foreground, to a glimpse of the former prisoner of war camp at Sudeley Castle in the distance. (© Crown copyright NMR [Harold Wingham Collection])

First published 2011

Amberley Publishing
The Hill, Stroud
Gloucestershire, GL5 4EP

www.amberley-books.com

Copyright © David Aldred & Tim Curr, 2011

The right of David Aldred & Tim Curr to be identified as the Authors of this work has been asserted in accordance with the Copyrights, Designs and Patents Act 1988.

ISBN 978 1 4456 0409 1

British Library Cataloguing in Publication Data. A catalogue record for this book is available from the British Library.

Typeset in 9.5pt on 12pt Celeste.
Typesetting by Amberley Publishing.
Printed in the UK.

Introduction

'Ancient Saxon Borough' read the welcome signs to Winchcombe. Although pre-historic and Romano-British finds have been made in the town, it's true that Winchcombe's fame belonged to the Anglo-Saxon period when it became an important fortified town of the ancient kingdom of Mercia. It possessed a royal abbey, later dedicated to St Kenelm, and in 1007 it became the centre of a shire which merged with Gloucestershire ten years later. It was even the site of a royal mint making coins. In fact, by the time Domesday Book was compiled in 1086, just twenty years after the Battle of Hastings, Winchcombe's glory days already lay in the past. Then during the Middle Ages the town made its living as a borough, where people could buy, sell and manufacture, governing themselves and free from the control of their landlords, the king and the abbey. The great abbey not only provided employment but brought pilgrims into the town and so its dissolution on 23 December 1539 was a severe blow to the prosperity of the area, leading to centuries of poverty and neglect. In fact the short-lived attempt to grow tobacco in 1619 was just one attempt to provide the people with jobs and income.

All this is background to our selection of images which attempts to reflect some of the features of the town and surrounding area over the last two hundred years. Here you will see a town which still retained some local importance with its shops and manufacturing, its schools and hospitals, its places of worship, and its markets and fairs. Although its medieval borough status came to an end in 1887, seven years later it was chosen as the centre of the newly-introduced Rural District Council (until 1935) and from 1834 to 1930 it served as the centre of a Poor Law Union. Yet as many of our images witness, Winchcombe still seemed somewhat cut off from the mainstream, not helped, of course, by its position beneath Cleeve Hill. Even the railway of 1905 kept its distance at Greet.

So in these pages you will see reflected a small part of the north Cotswolds over two centuries. Centred on Winchcombe we reach Stanway House and estate in the north, superficially unchanged; in the east Sudeley Castle has been transformed from ruin to stately home and major visitor attraction; to the south the ancient burial mound at Belas Knap has been completely rebuilt and in the west elements of both continuity and change can be found in the village of Gretton. Today, Winchcombe retains an historic character oozing out of the buildings which line its main streets. Since the 1970s new housing has continued to rise on its fringes to bring liveliness and activity to the town. Its shops remain overwhelmingly locally-owned and busy and if the teashops, antique shops and art galleries appeal more to the visitor, they ensure a vitality which keeps the town thriving. We have made a conscious effort to capture the vitality of 2011 in our modern photographs. We have also indicated in our captions where readers can find out more of Winchcombe's history. So we hope our selection will therefore serve not only as an historic record, but also a modern one, bringing pleasure to both resident and visitor alike.

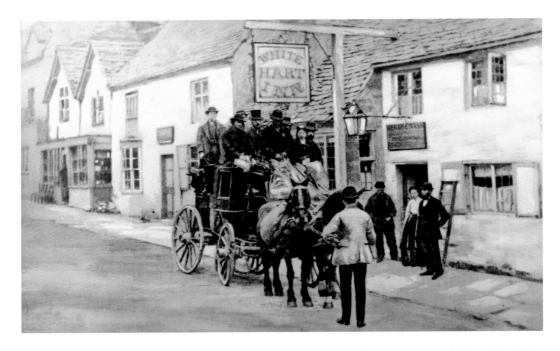

In 1868, Thomas Court started a coach to Cheltenham running three times a week from the White Hart Inn on Tuesday, Thursday and Saturday, leaving at 9.30. This photograph could well have been taken to record the first journey. George Nash was not only the landlord of the White Hart, but also of the George at that time.

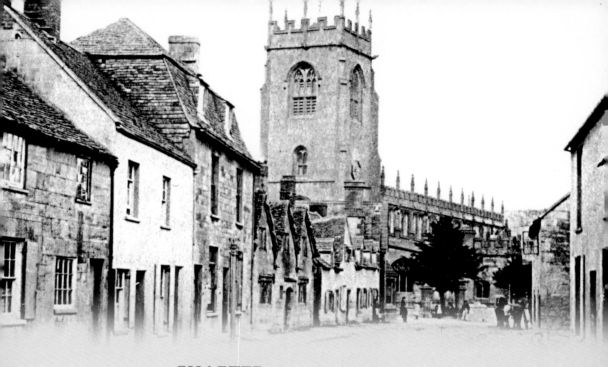

CHAPTER 1

Winchcombe

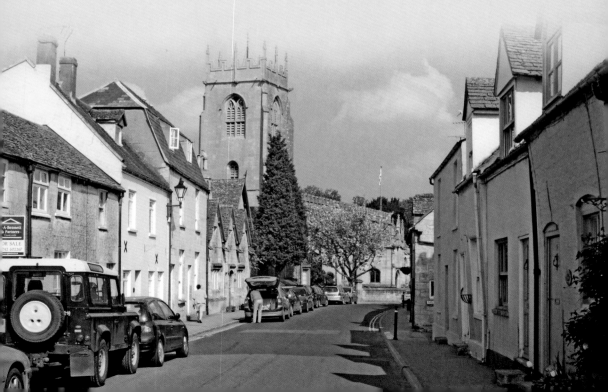

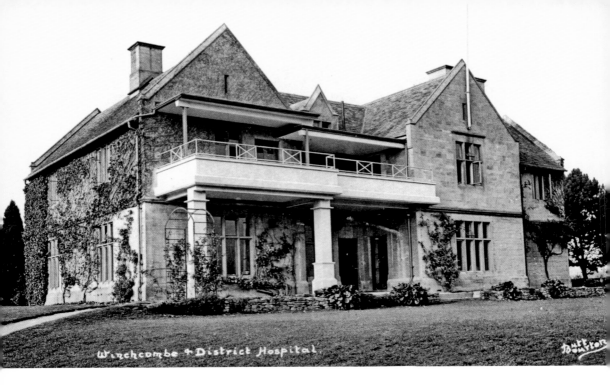

Winchcombe + District Hospital.

From Local Pride to State Prefab

We start our historic tour of Winchcombe from the south. The district hospital stood above the Cheltenham Road and reflected local pride when opened in 1927. By the end of the century it was said to be too expensive and unsuited to modern medical practice. The replacement outpatients' department might be more appropriate for modern demands but will never win prizes for architectural merit.

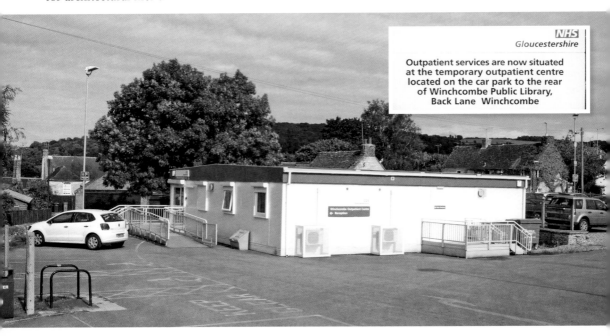

NHS
Gloucestershire

Outpatient services are now situated at the temporary outpatient centre located on the car park to the rear of Winchcombe Public Library, Back Lane Winchcombe

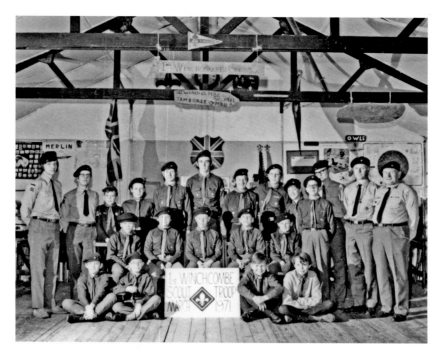

Scouting for Boys (and Girls)

Winchcombe scouts have a long and proud history dating back to 1908 as one of the very first scout troops, comprising ten boys and eleven girls under the presidency of Eleanor Adlard of Postlip. Here the cubs and scouts are photographed in March 1971 with their leaders including Vincent 'Digger' Dring and Bill Barton. The inset shows this year's very successful open evening held in June to which both boys and, once again, girls were invited.

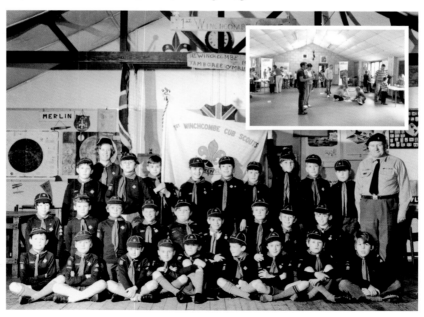

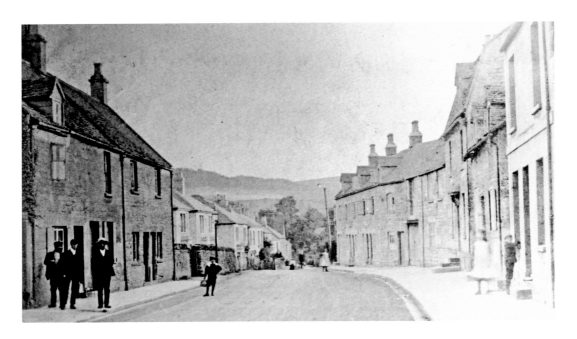

Gloucester Street

In the Middle Ages this part of Winchcombe lay outside the borough and was called *Throp*. Parts of the houses on the right probably date back to this period, but by the time of the earlier photograph, a postcard posted in 1906, they looked like most Cotswold stone cottages. The houses lower down facing them were much newer. The road led down to the Postlip paper mills where paper has been made since at least the eighteenth century. Perhaps the three men were on their way home after a day's work.

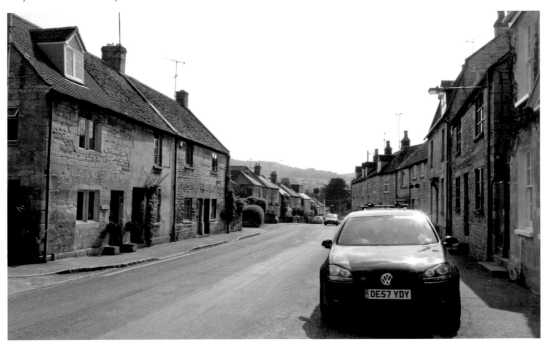

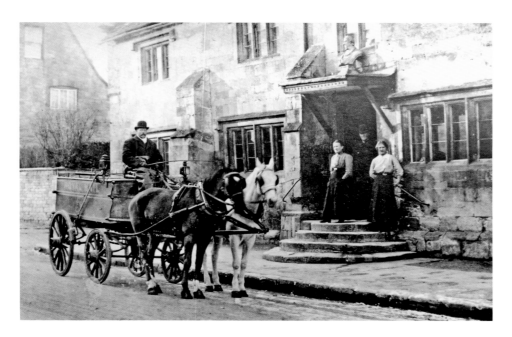

The Corner Cupboard Inn

The medieval borough ended at this corner. Until 1872 the building was a farm and in 1937 John Oakey could remember how Farmer Holiday's bull was kept in the backyard and terrorised him and his friends (no doubt with good cause!). The Richardson family were the original licensees and they appear in this photograph taken on the last day of 1913 to record the final horse-drawn delivery of post from Cheltenham. Then, as now, the bust of Benjamin Disraeli looks down from the porch roof.

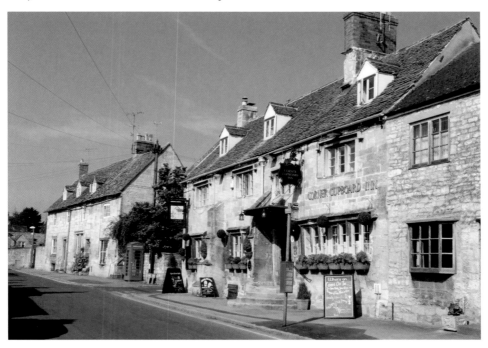

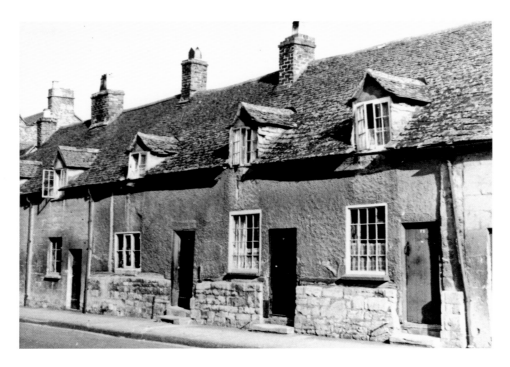

An Old Barn

Opposite the Corner Cupboard stands this medieval barn to remind us of Winchcombe's farming history. At some time in the eighteenth century it was converted into three cottages, windows were inserted in the wall and roof and the stone sill was cut for three doorways. The earlier photograph was taken in 1952 before the rendering was removed to expose the original timbers. Today the central door has been blocked and the sill recreated.

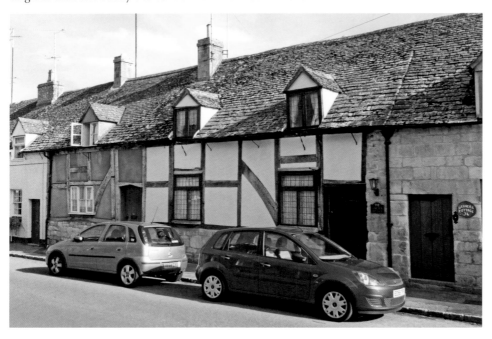

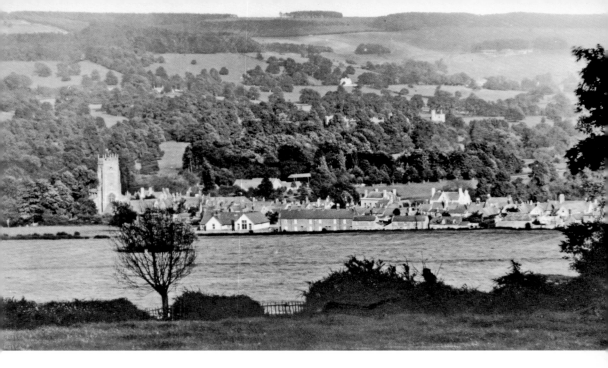

Winchcombe from Langley

At first glance these pictures of the southern part of the town appear the same, but look more closely and it will be noticed that the buildings in the pre-war photograph are along Back Lane, but those in the modern view are in Abbots Leys Road. The ridge and furrow of the medieval borough's infield ('Enfield'), used for growing crops, was built upon in the second half of the last century. Yet St Peter's church is still visible and Sudeley Castle can just be seen above the trees in the distance.

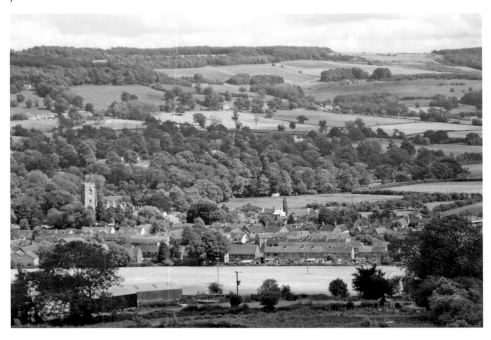

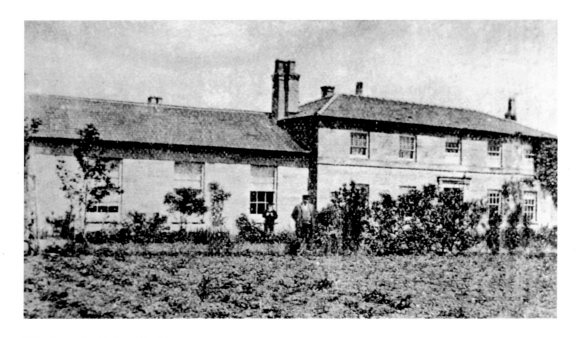

Winchcombe Union Workhouse ...

The workhouse was opened in 1837 to provide for the desperate poor of the town and twenty-nine surrounding parishes in spartan conditions. The census of March 1851 recorded eighty-two inmates, including thirty-three old people and twenty-one orphaned children. The rest comprised single mothers and their child(ren), destitute families and a few vagrants. The upper illustration shows the front and the lower illustration is an enlargement from the aerial view on page 2, by which time the central block had been demolished.

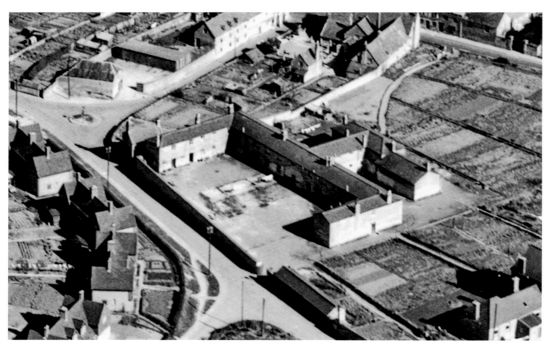

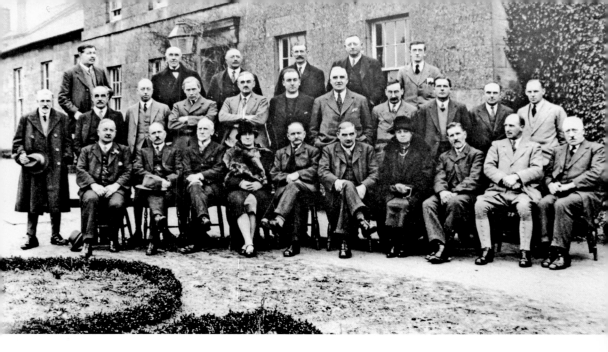

... and its End

These local worthies were photographed at the last meeting of the guardians, who had met every month to ensure the proper running of the house. By 1930, when the photograph was taken, measures such as old age pensions, introduced in 1908, had helped remove the need for the workhouse. The buildings were then used as a home for boys before being demolished in the 1950s and have now been replaced by a sheltered housing complex for the over sixties.

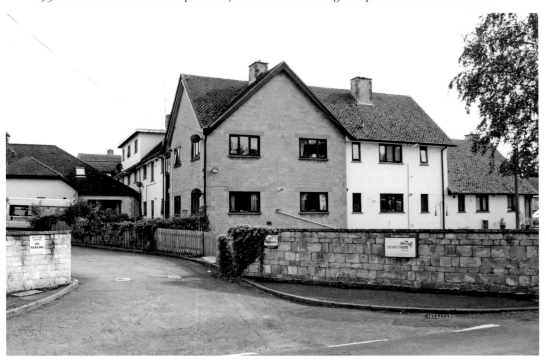

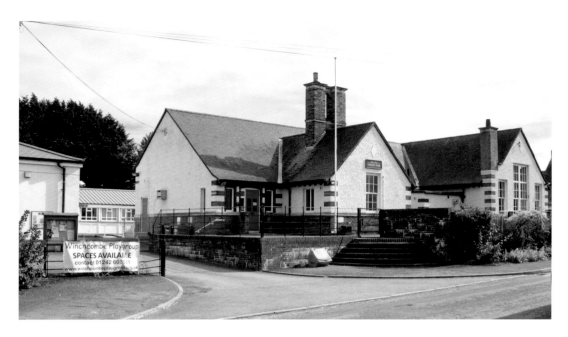

Abbeyfields Community Centre

The centre was built as an infants' school in 1911. It later became the girls' school, then in 1952 the secondary school, before the present school was built in Greet Road ten years later. The earlier photograph was taken shortly after this change, when it had become the town's primary school. It was in 2005 that it became the community centre. As can be seen in the modern photograph, a playgroup meets on the site, as do many other user groups. The town council meets here; the police have a presence and for a weekend in May it becomes the heart of the very successful Winchcombe Walking Festival.

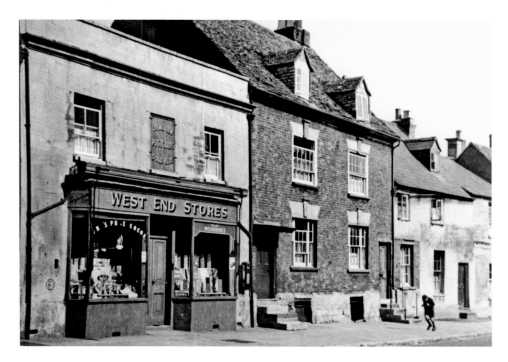

'The Pounds, Shillings and Pence Shop'

Caroline Shekell opened a grocery shop here before the Great War. In his *Reminiscences* John Oakey tells us how he converted the Lower Packhorse Inn into the West End Stores. Older residents might still recall how Arthur Shekell continued to mark his prices in pounds, shillings and pence after decimalisation in 1971 until the shop closed in 1980; some thirty years after the upper photograph was taken. Since then it has been converted into a house, with the name Lower Packhorse Cottage to commemorate the inn. Behind the frontage stands an almost complete sixteenth-century timber-framed house, whilst next door is the town's only eighteenth-century brick-built house.

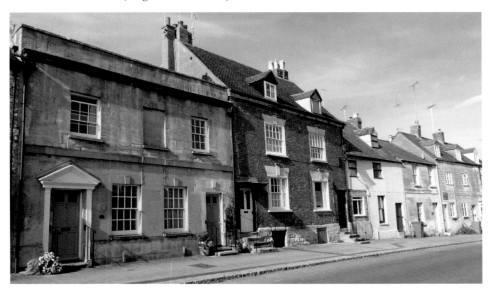

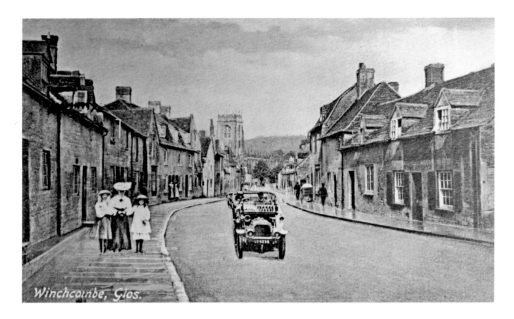

Winchcombe, Glos.

Gloucester Street

From this point onwards, the soaring tower of St Peter's dominates the view. We love the top scene as it shows how photographs were manipulated long before the digital age! In it a horseless carriage and three fashionable ladies have obviously been superimposed to update an earlier scene, probably from the end of the nineteenth century. We were fortunate that a vintage MG sports car was passing through to give an added interest to our modern photograph.

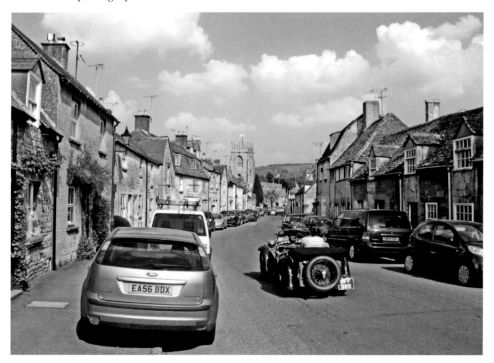

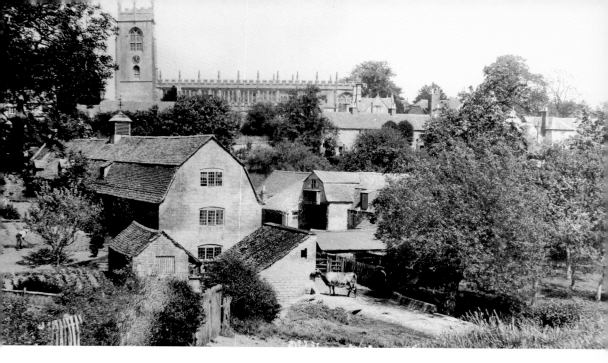

The Town Mill I

Before arriving at the church, Mill Lane on the right leads to a small residential development, built on the site of the town mill after its demolition in 1973. There had been a flour mill here since at least the Middle Ages and parts still survived beneath the later buildings seen here in a postcard sent in 1952. No trace remains today of the mill and its ancillary buildings, but the church and the low wall of the bridge over the River Isbourne in the foreground provide points of reference for comparing the scenes.

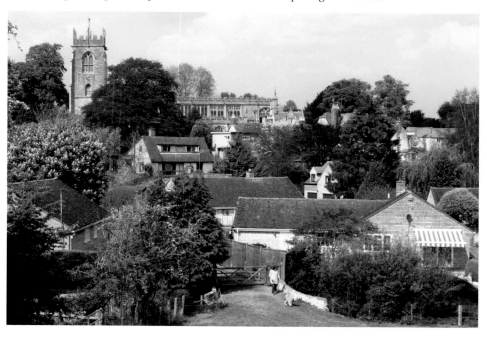

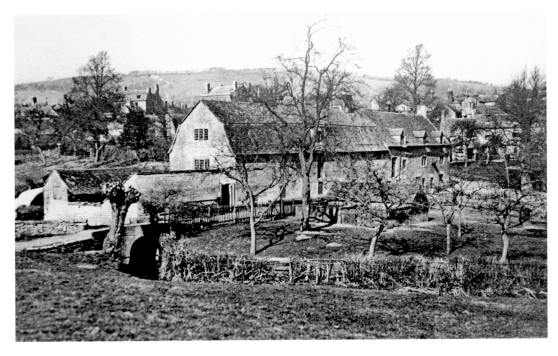

The Town Mill II

This second view of the old mill from the south-east provides another perspective of the mill buildings. Readers whose memory goes back before the war might remember the *Thistledown* brand of flour. Those who remember the mill more recently before its closure might remember its *Winflo* brand.

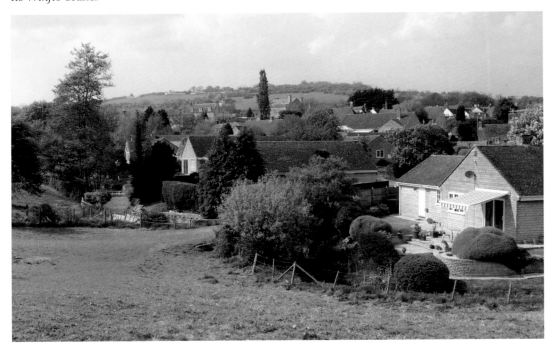

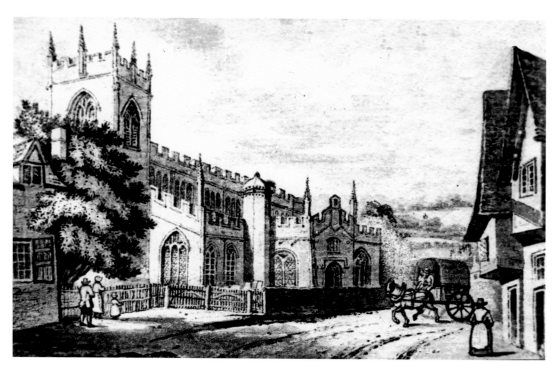

St Peter's Church from Gloucester Street

This engraving of 1826 is full of interest, even allowing for some artistic licence. From this angle the church looks much the same as today, but the buildings in the foreground have changed and so has the mode of transport! The medieval timber-framed buildings have gone and Beech Cottage on the left was demolished in 1867 to make way for Emma Dent's National School.

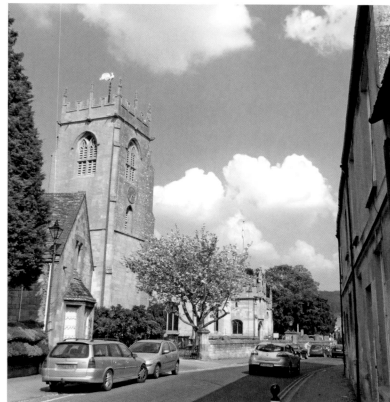

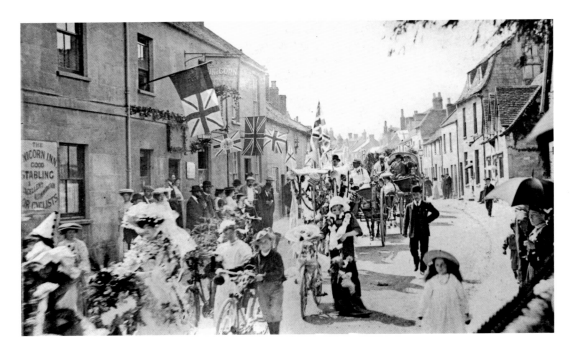

Carnivals

Carnivals have featured in the lives of Winchcombe townsfolk for generations. In my *Bishop's Cleeve to Winchcombe in Old Photographs* I speculated the top picture might have been taken of the 1911 coronation carnival. Further evidence now suggests it could have been the carnival to celebrate Queen Victoria's jubilee of 1887, the *Evesham Journal* recording 'from the windows of numerous houses hung flags of all sizes and descriptions'. Fortunately the date 1907 has been engraved on the lower photograph. Both processions were probably on their way to Sudeley Grounds for the celebrations.

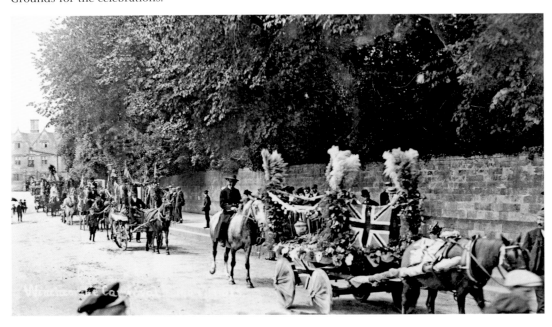

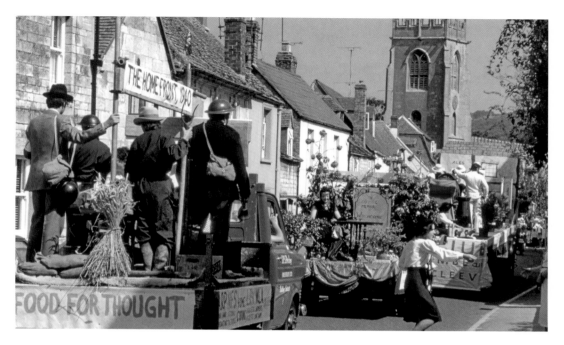

More Carnivals

The Second World War seems to have been the theme for a carnival in the early 1970s shown in the top photograph. The bottom records the Happenstance morris men and women passing the long-closed Unicorn Inn and playing their part in the procession which proceeded the sixty-third Winchcombe Country Show on August Bank Holiday Monday 2011. The procession had started at the Abbeyfields Community Centre and still had a long way to go to reach Winchcombe School in Greet, where the shows now take place.

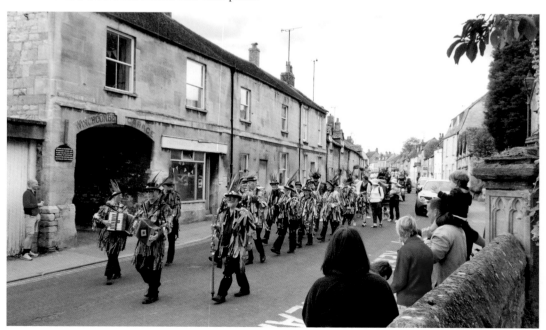

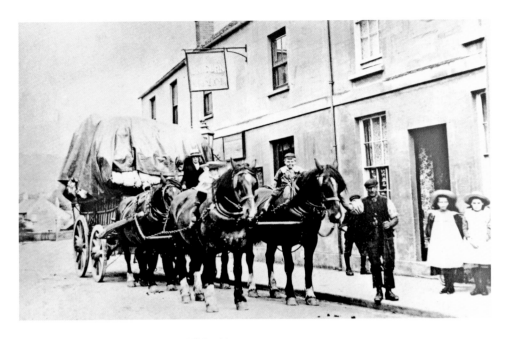

From Horse-Drawn Wagon to White Van

For centuries Winchcombe's long distance trade had been via the river at Tewkesbury. When the railway reached Beckford in 1864 much of the trade transferred to rail. The earlier photograph from *c.* 1905 shows a wagon heavily laden with rags pausing outside the Unicorn Inn on its way from Beckford to Postlip paper mills. Few heavy lorries now drive through Winchcombe and so the recent photograph captures a ubiquitous white van, the symbol of modern freight transport, in exactly the same spot. John Oakey tells us that the Unicorn Inn closed before 1935.

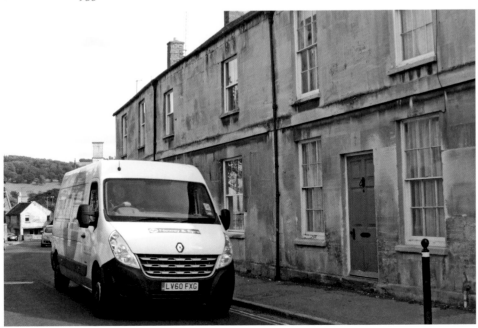

St Peter's Church

The present church was largely built in the 1450s and 1460s as a joint effort between Abbot William, the townspeople and Sir Ralph Boteler of Sudeley. The engraving shows the Ladies Gallery, for the principal inhabitants of the town, which was removed in a major restoration of the church in 1872. The wooden screen shown in the second view, in a postcard dated 1906, has been relocated to the back of the church, so creating the large space seen in the lower photograph which shows a choir rehearsing for a summer wedding.

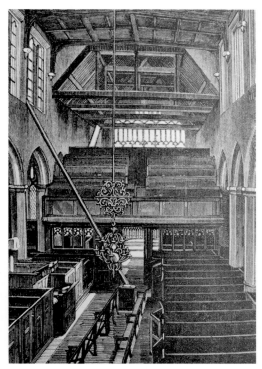

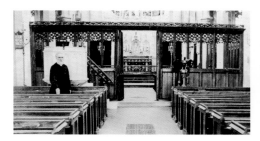

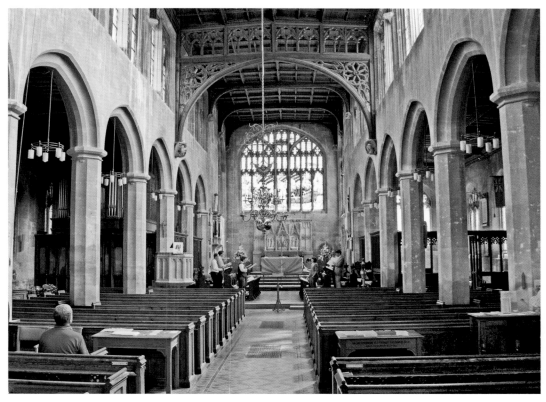

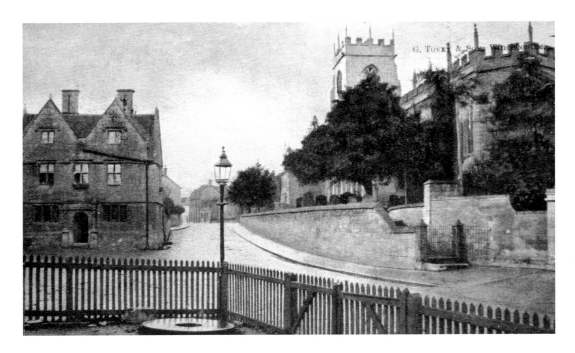

Jacobean House

In his history of Winchcombe, David Donaldson recounts how John Barksdale, the town's high bailiff, built 'the Newe Schole Howse' for the King's School in 1618 at a cost of ten pounds and ten shillings. Since then the Jacobean House has dominated Queen's Square. The schoolroom lay on the ground floor and the master's accommodation above it. In this postcard sent in 1906, the fencing in the foreground separates John Bostock's blacksmith's workshop, with its wheelwright's platform, from the public highway. After the Great War it became the Cotswold Garage and significantly, even in 2011 the area is still marked as private property.

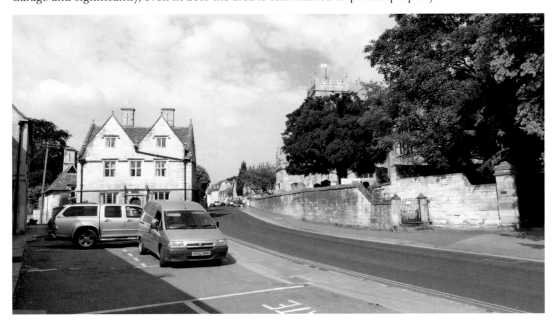

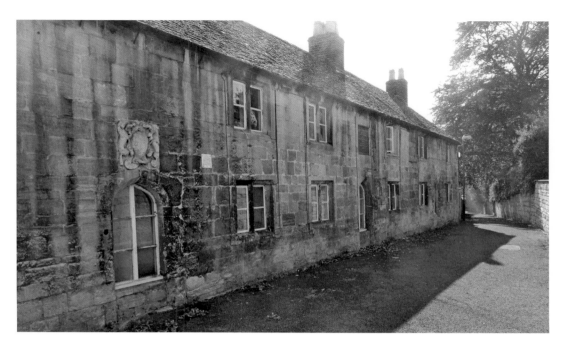

The Chandos Almshouses

Almshouse Lane now forms an atmospheric quiet backwater off Queen's Square, but there is evidence that it was the earliest route south out of the town before 1200 and the creation of Gloucester Street. These almshouses were the gift of Lady Dorothy Chandos of Sudeley Castle in 1573. At that time the town was suffering economically from the loss of the abbey and so she provided apartments for twelve poor people. They were much altered in 1841 but since the lower photograph was taken a century ago, little has changed.

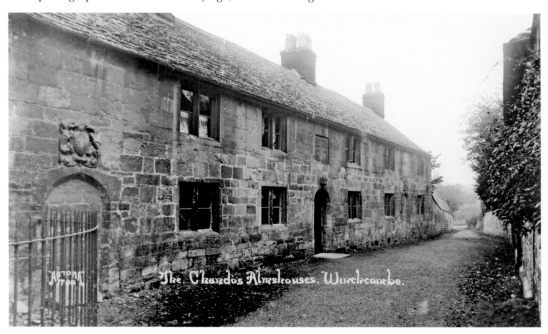

The Chandos Almshouses, Winchcombe.

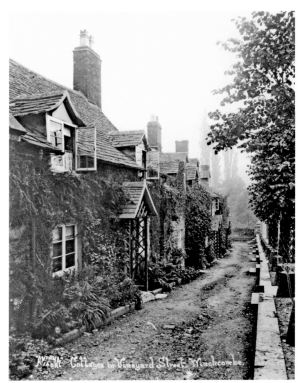

Cottages in Vineyard Street
Nearly a century separates these two views of the cottages and we have chosen them to show another part of the town where little seems to have changed, although we have managed to keep the parked cars out of our view! Only the line of television aerials sprouting from the chimney stacks indicates the march of modern progress. The cottages are medieval in origin and until 1891 stood alongside a road which led only to Brockhampton.

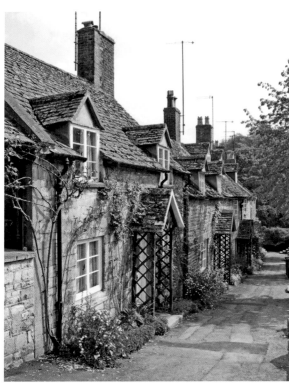

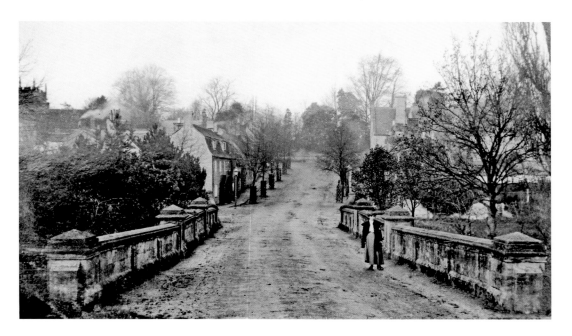

Vineyard Street Bridge

Vineyard Street was also called Duck Street. According to Emma Dent in her *Annals of Winchcombe and Sudeley*, elderly inhabitants in 1850 could remember how scolding women were ducked in the River Isbourne to cool their tongues! At that time the bridge was only two feet above the river and when John Oakey built the existing bridge in 1891, he claims to have found the stump of the old ducking stool. The new bridge was part of the new approach to Sudeley Castle which linked it and the town much more conveniently than the original route to the castle at the bottom of Sudeley Hill.

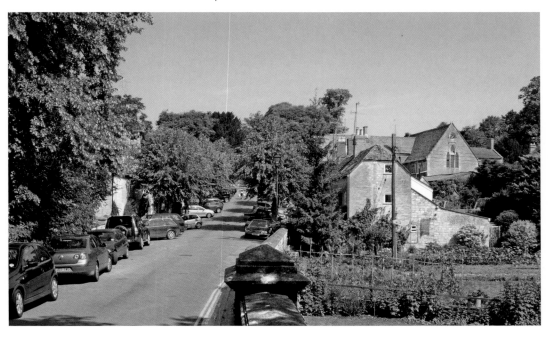

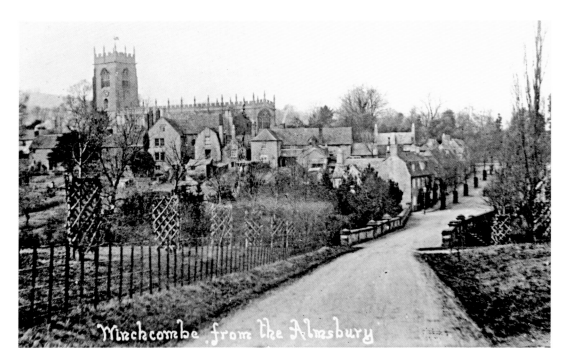

Winchcombe from the Almsbury

View from the Almsbury

We have two copies of this postcard posted in 1910 and 1921. By the later date the saplings, probably planted shortly after the new approach to Sudeley Castle had been completed, must have begun to obscure the view. Nearly a century later they have burgeoned so that the modern photograph has had to show a more southerly aspect of the town. Almsbury Farm, just out of picture to the right, had belonged to the abbey. It now belongs to the Sudeley Estate and in 2011 still awaits final redevelopment and rebuilding after a disastrous fire in 2003.

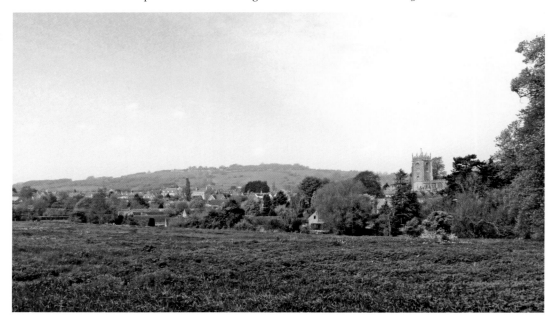

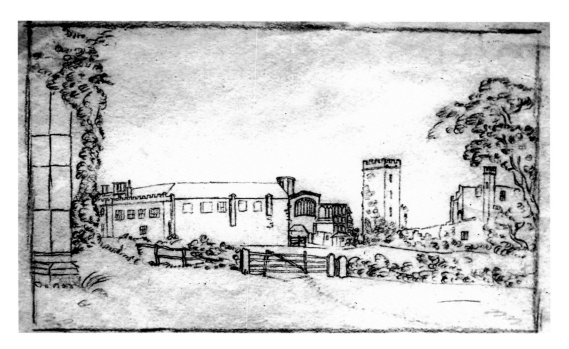

'Sudeley from the North West'

This is the first sketch in our volume drawn by Edmund Thomas Browne, a prominent Winchcombe worthy with a keen interest in history, who drew several scenes around the town between 1813 and 1820 – well before the days of photography. At this time part of the castle had been turned into the Castle Arms to cater for the visitors to what was then considered a romantic ruin. They were following in the footsteps of King George III, who had visited the castle when staying in Cheltenham in 1788. The sketch has been made from a point about halfway down the left edge of the more modern aerial view.

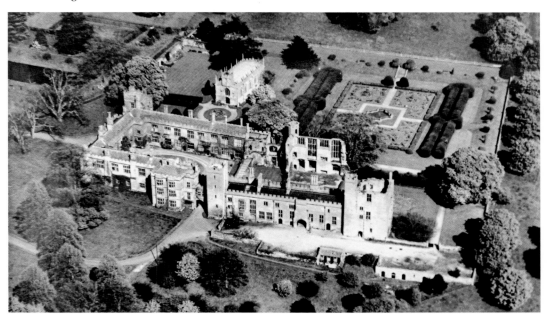

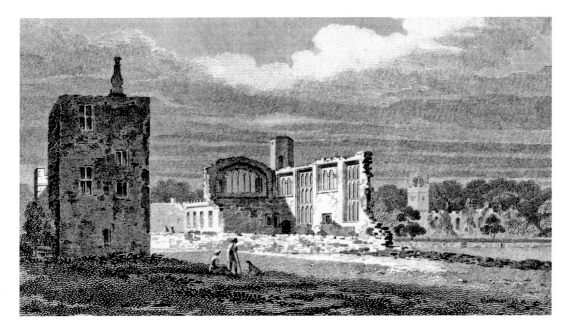

Sudeley: From Ruin ...

The three views on this double page very largely show the same scene. The first shows the castle at a slightly earlier date than the previous sketch. Once the home of Henry VIII's sixth wife, Catherine Parr, it was deliberately ruined in 1649 after the English Civil War to prevent its being used as a future stronghold against Parliament. Its transformation from romantic ruin to a stately home began when John and William Dent, the Worcester glove makers, bought it in 1837. The lower picture shows the same scene in the early twentieth century, shortly after the death of Emma Dent, who had continued the restoration.

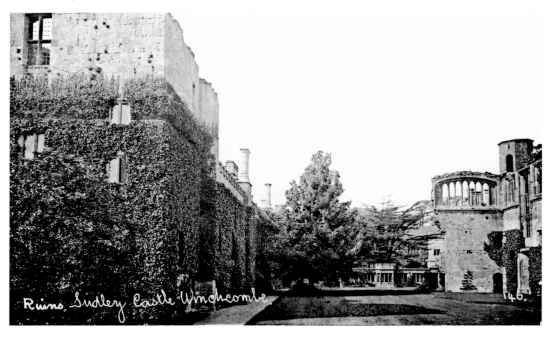

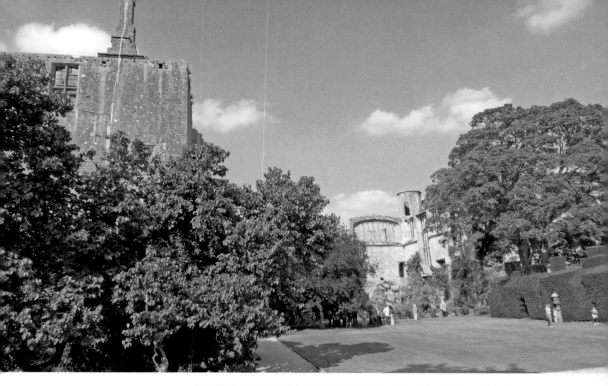

... to Visitor Attraction

Today Sudeley Castle is a popular tourist destination, as can be seen in the top photograph. As part of the attractions for 2011 an outdoor exhibition of sculpture under the title 'Material Worlds' was mounted. The lower photograph is entitled 'A Bunch of Flowers' and is made up of thousands of aluminium flower heads. The inset shows the colourful 'Bee3', made out of recycled material. They encapsulate the spirit of modern Sudeley, appealing to the visitors to bring in the income needed to keep the castle in good repair.

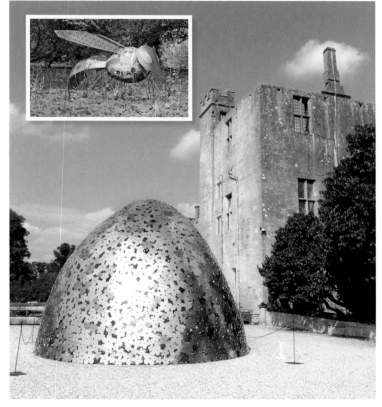

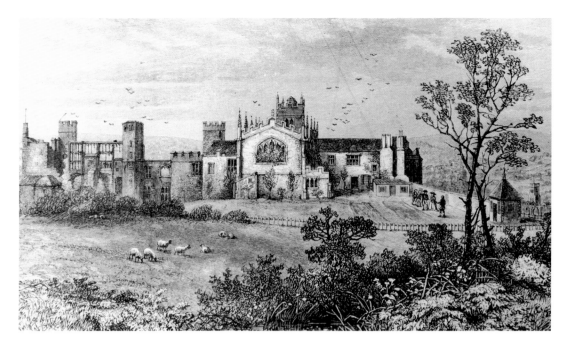

Sudeley Chapel

No visit to Sudeley is complete without a visit to its chapel, burial place of Catherine Parr. The engraving dates from 1789 and shows a very rural, but fashionably picturesque scene. Although it's not obvious from the illustration, at that date the chapel and tomb lay in ruins. Despite misgivings from many local people, Emma Dent went ahead and paid for the restoration of the chapel and tomb in 1863, so that today it provides one of the castle's highlights. The growth of trees and bushes in the last two centuries has meant it has been impossible to replicate exactly the scene portrayed in the engraving.

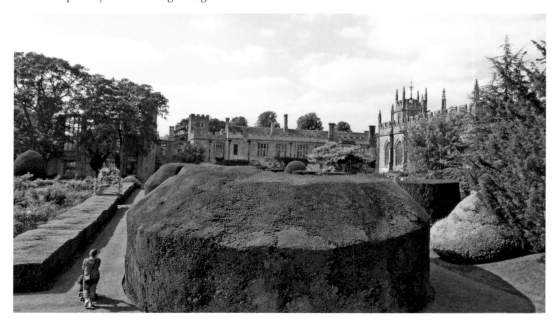

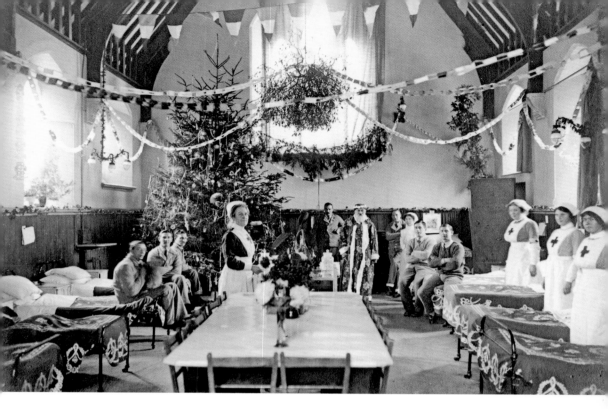

VAD Hospital

This building on the corner of Vineyard Street has seen many uses during its lifetime. 'Infants school 1857' is inscribed above the far upper window, but it has also served as a drill hall, assembly rooms and as a VAD hospital for wounded soldiers during the Great War. VAD hospitals were run by volunteers. The formidable Miss Eliza Wedgwood of Stanton Court was the commandant helped by two trained nurses and seven volunteers, some of whom are seen here with Father Christmas during wartime Christmas celebrations.

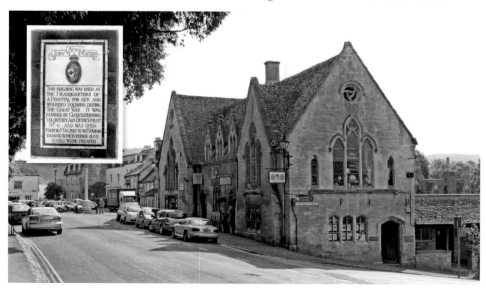

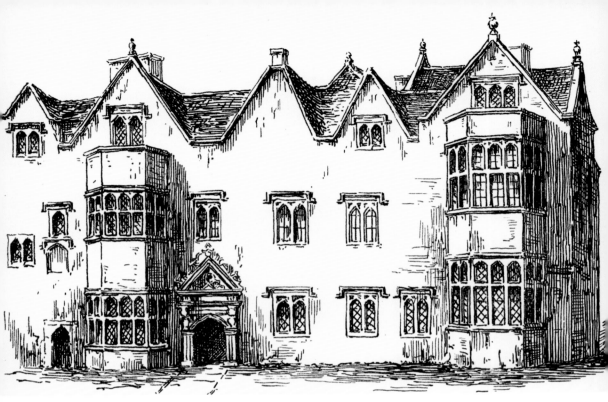

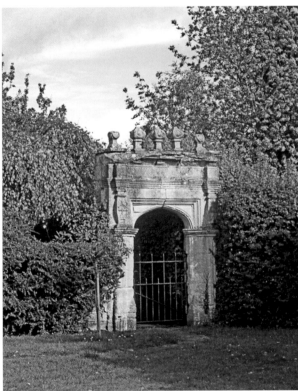

Winchcombe Abbey I

When the abbey was dissolved on 23 December 1539, it left a gap in the heart of Winchcombe and its stone was soon re-used throughout the town and at Sudeley Castle. One of the few buildings which survived was the abbot's house, seen here in an illustration based on a sketch by Edmund Browne shortly before its demolition in 1815, when it was serving as the town's poor house. It had been enlarged after the dissolution, but all that survives today is the gateway. A few rescued tiles are on display in St Peter's church, where John Stevinson's valuable publications on the abbey can be obtained.

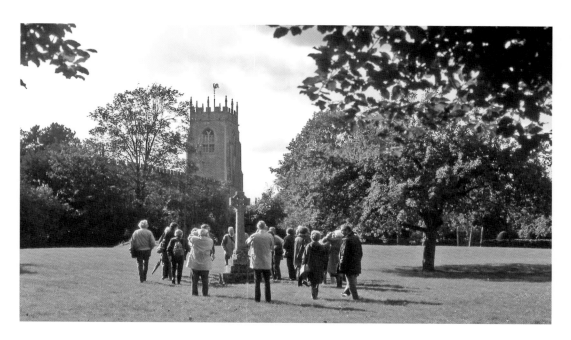

Winchcombe Abbey II

The abbey site has continued to fascinate people. Archaeological digs took place in 1892 and then by Birmingham University students soon after the Second World War, but few remains were found. After the dig in 1892 Emma Dent erected a cross to mark the central part under the tower. During the 1990s Bristol University ran a series of popular day schools about the vanished abbey and the upper photograph records students viewing the cross in 1996. The lower scene shows part of the site being used for the 'Garden Evening' organised by the town's churches on the very wet evening of 24 June 2011. The grounds are private gardens.

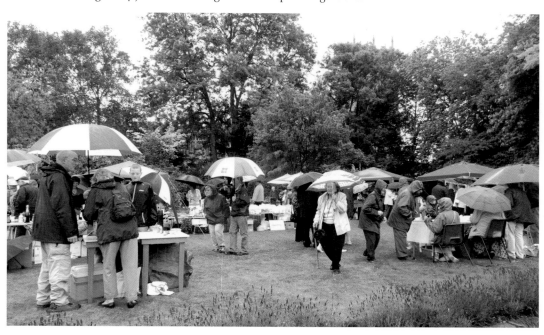

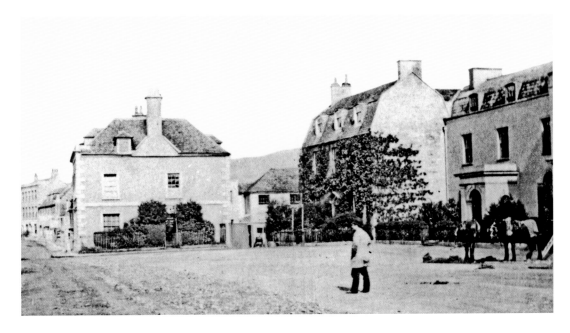

Abbey Terrace: From Open Space ...

In 1837 the abbey grounds were cut back to their present line, so opening up Abbey Terrace. These four views show the terrace's changing nature down the years. The earliest view dates from before 1887, the year of Emma Dent's gift to the town of a fountain to mark Queen Victoria's jubilee. The lower view dates from shortly after 1920 when the war memorial was unveiled to commemorate the seventy-eight men who gave their lives for their country. In the background, the original fountain had been replaced by a new granite fountain presented to the town in 1910 in memory of John Waddingham of Guiting Grange.

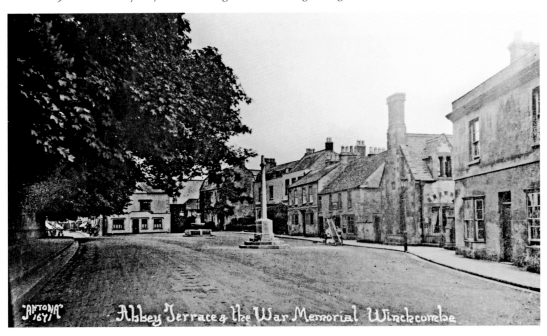

Abbey Terrace & the War Memorial Winchcombe

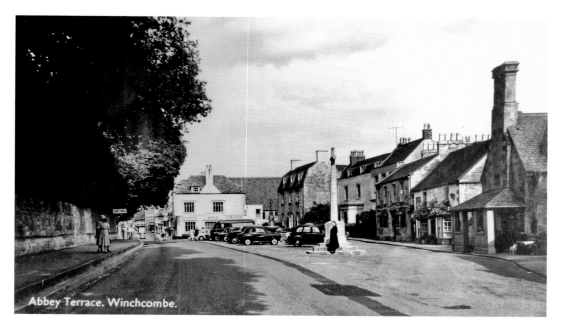

Abbey Terrace, Winchcombe.

... to Car Park

Fifty years ago when the top photograph was taken, the terrace was taking on its modern appearance as a car park. Today the space is no longer adequate for the demand and so parking is limited to two hours and cars also park along the road itself, but some people still prefer to cycle! Unfortunately, the cars can so easily detract from the attractive historic buildings in the terrace. The building with the red stones arched above the window marks the end of Dents' almshouses built on the site of the Bell Inn in 1865 at a cost of £4,000 (see also page 55).

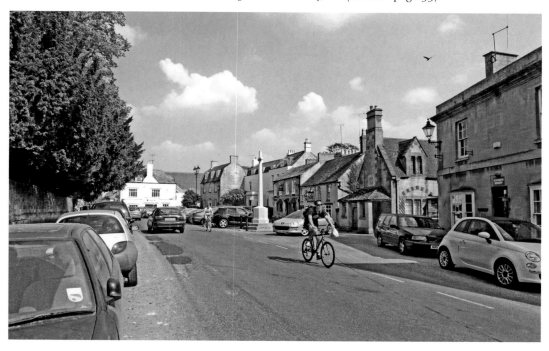

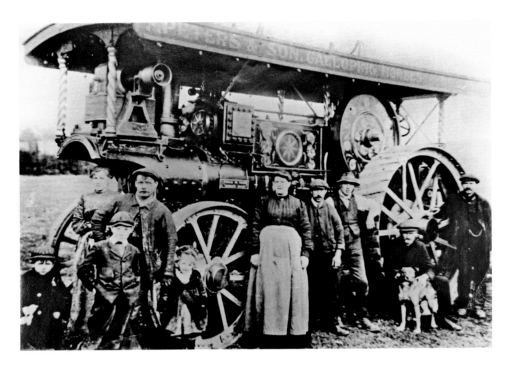

The Mop Fairs

The mop fairs have been an important event in October in Winchcombe for centuries. Originally designed for the hiring of servants for one year, even by John Oakey's childhood in the 1870s they were more appreciated for the sideshows and stalls. In 1910 Alf Peters of Worcester (wearing a trilby) is seen with admirers in front of his 'Duchess of Worcester' traction engine used to power his gallopers and light show. In 1985 a big wheel almost fills Queen's Square and the recent view shows how cars have to park elsewhere than Abbey Terrace!

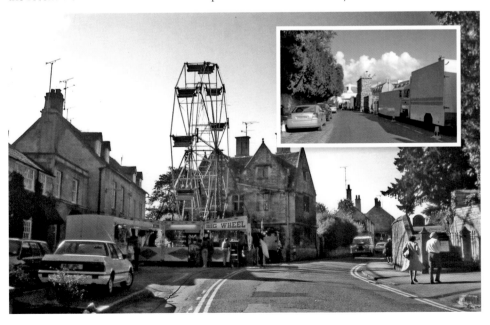

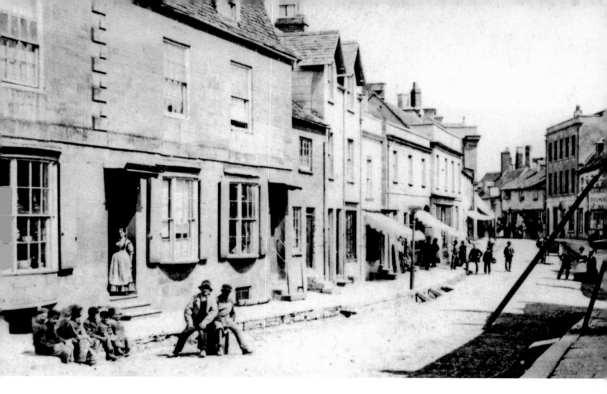

High Street looking North

Both views are full of interesting detail and the scenes are remarkably similar, although the older view pre-dates the building of the present Methodist Church in 1885. It is one of the photographs from the collection of the late Harold Greening, now held at the museum. The later view just captures one of the popular monthly sales of bric-á-brac which were held at the church during the summer.

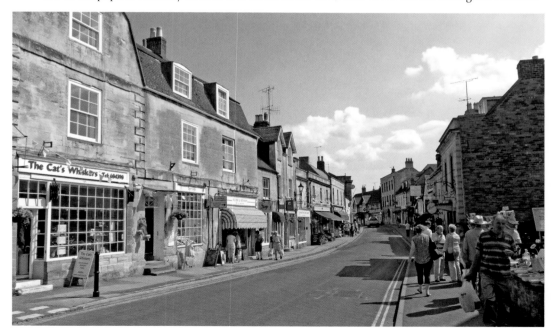

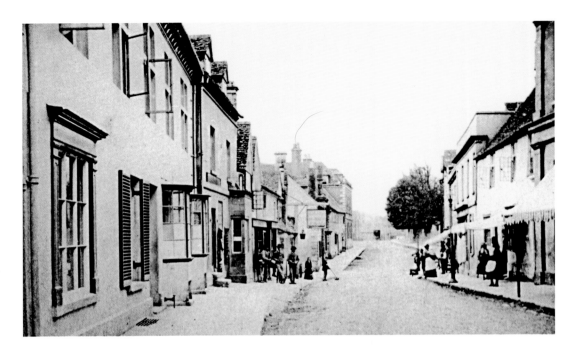

High Street looking South

The older view was obviously taken at the same time as the one on the previous page, just showing the cottages which were demolished for the Methodist Church. Note the street sweeper working in the middle distance. No modern collection of photographs would be complete without a Castleways bus, linking the town with Cheltenham, Broadway and Willersey. At this point, the rows of double yellow lines ensure it and the rest of the traffic can at least enjoy a smooth flow through the centre of the town!

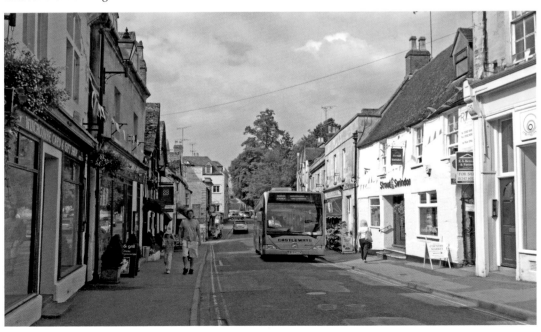

'Georgean House'

The road by the side of the White Hart, often referred to as the pitch, led to the main entrance to Sudeley Castle until 1891. At the bottom of the pitch still stands the Great House, dating back to the seventeenth century, long before the Georgian period. This scene has changed very little over the last century, but the lane to the right in the modern photograph led to the silk mill, which from about 1820 to 1872 provided employment for large numbers of women and children of the town. Its stone was used to build what is now the Cotswold Christian Centre in Gretton Road.

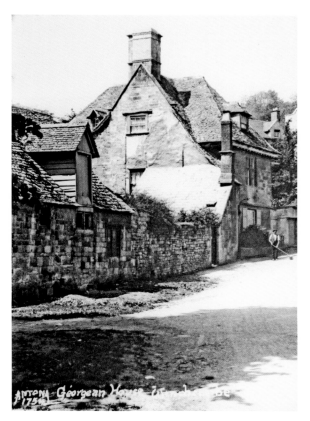

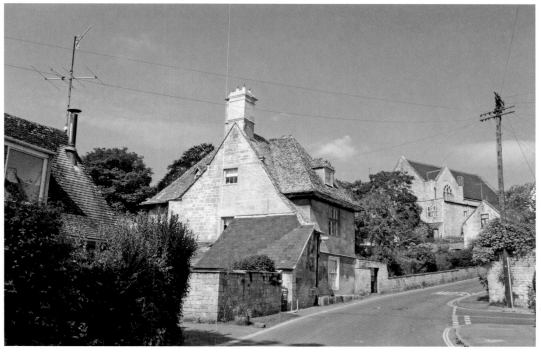

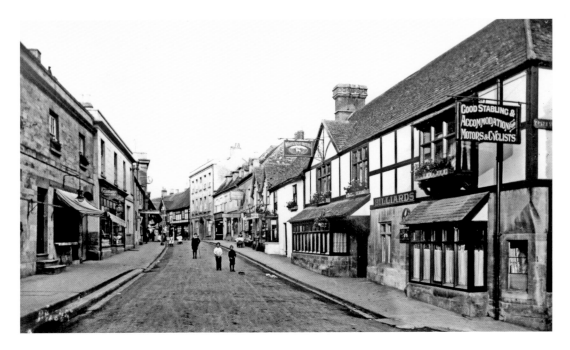

High Street and the White Hart Inn

The White Hart, taking its name from the personal emblem of King Richard II (1377–99), has played an important part in Winchcombe's history. It was used for auctions in the past and the starting point for Thomas Court's coach to Cheltenham (see page 4). That photograph captures it before its rebuilding by Emma Dent in 1882 to make it look more ancient. Since then it has remained remarkably unchanged and now promotes itself as 'a sixteenth century inn with a wine and sausage restaurant'. The upper picture dates from just before the Great War.

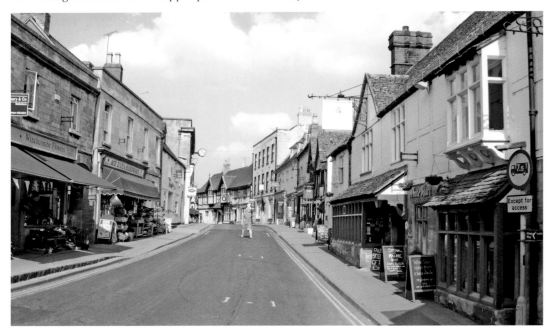

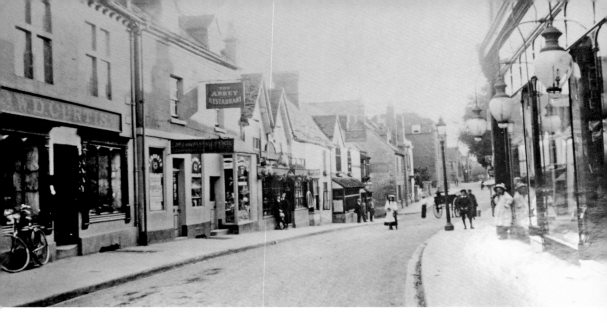

High Street with the Abbey Tearooms

Here is another view of the commercial premises in the High Street dating from the early years of the twentieth century. Again the interest is in the detail of the buildings. As David Donaldson has written in his book, 'An undervalued component of Winchcombe's fabric is its shop fronts.' Such little change in their general appearance helps to give Winchcombe its air of an historic town and so helps to prevent wholesale change. Kate Horlick ran the Abbey Tearooms from 1906 to the Great War. Older readers might remember Curtis' outfitters during the first half of the last century.

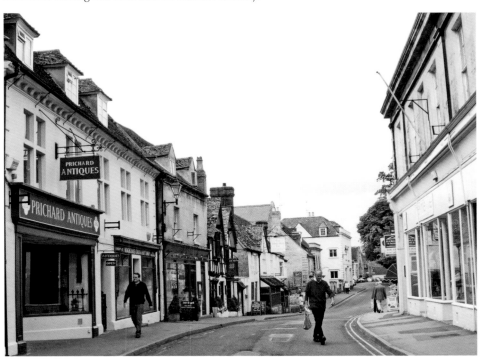

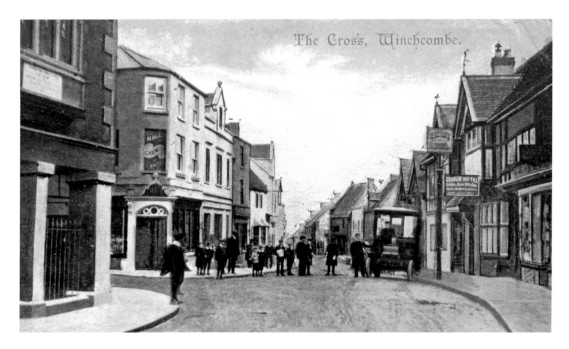

The Cross looking North

We make no apology for including another picture of the cross in our selection, for the earlier photograph here captures a short-lived episode in the history of the town. When the railway reached Greet from the north in February 1905, the Great Western Railway introduced a motor bus service to Cheltenham starting from the George and travelling to Greet, Gretton and on through Gotherington and Bishop's Cleeve. The number of people posing in the photograph suggests this was the very first journey. The bus made the journey three times a day until the railway reached Bishop's Cleeve in June 1906. Hall's chemist was a feature at the cross from 1878 until the Great War.

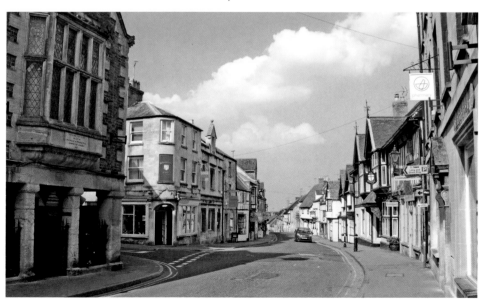

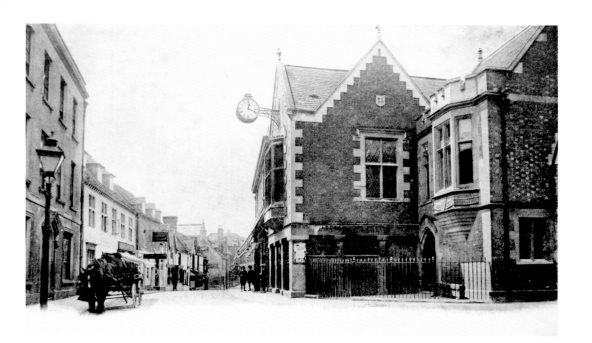

Town Hall and High Street

The cross has long been regarded as the town's centre. The present town hall was opened in 1854 at a cost of £367, replacing earlier buildings which had become very dilapidated. Part was built on columns to give a small covered area for the market. It was extended in 1871 and housed the town corporation until it was abolished two decades later. It also served as the magistrates' court, but for the last twenty years has been the home of Winchcombe's fascinating folk and police museum. This year's photograph has captured an advertisement for the walking festival in May; part of the very successful 'Winchcombe Welcomes Walkers' initiative.

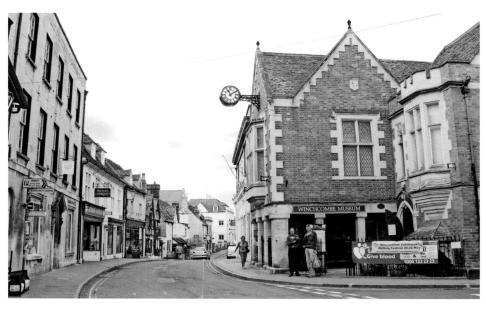

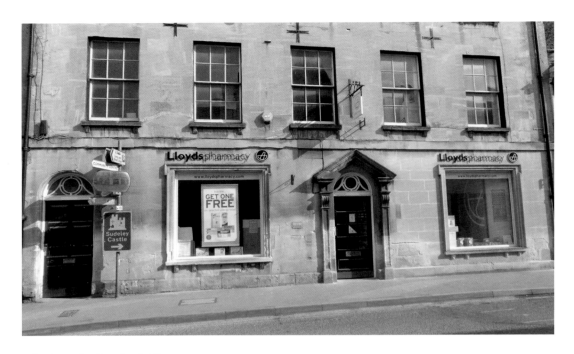

Winchcombe Butcher's Then ...

The building on the extreme left of the previous page is Lloyds pharmacy seen from a better angle above. Once the home of a member of Winchcombe's professional class, it later became a butcher's shop. Despite being a well-known photograph, we know little about the Victorian scene here, except it was captured before the George Inn next door was remodelled in 1884. Note the massive pair of steer's horns mounted over the doorway as a trading symbol. The al fresco display on trestle tables on the pavement reflects a bygone age long before health and safety legislation!

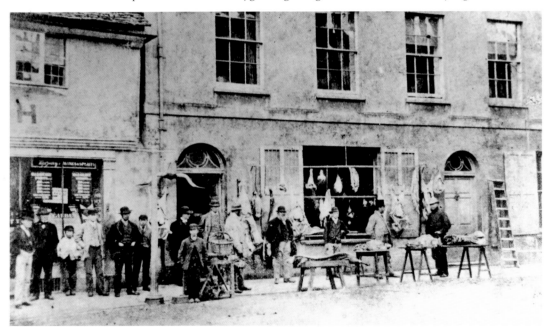

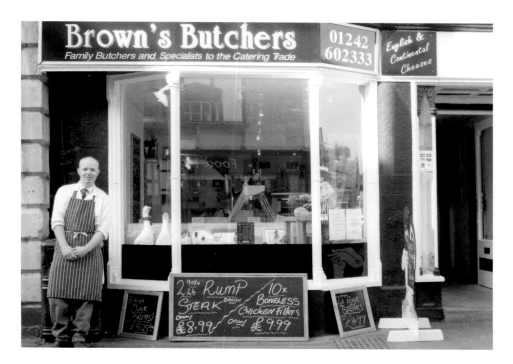

... and Now

Modern hygiene standards are very high and so only blackboards stand outside to lure the shopper into the shop to make a purchase. In 2008 Peter Campion recorded the town's shops and shopkeepers and we are grateful to him for allowing us to use them to make a fascinating 'then and now' comparison across these two pages.

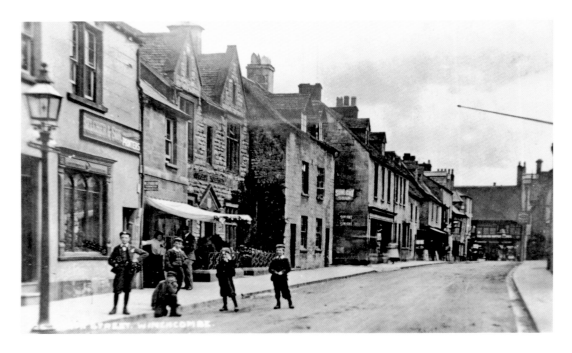

North Street looking to the Cross

John Oakey reminds us that many small cottages, including his own family house, were demolished in the second half of the nineteenth century to be replaced by buildings which still survive. Noteworthy among these is the stone building with the two gables behind the boys. This was the cottage hospital built in 1888 as yet another commemoration of Queen Victoria's golden jubilee. It cost £473 despite the fact that Lord Elcho at Stanway provided all the dressed stone used on the front at his own expense. It remained in use until the district hospital was built above the Cheltenham Road (see page 6).

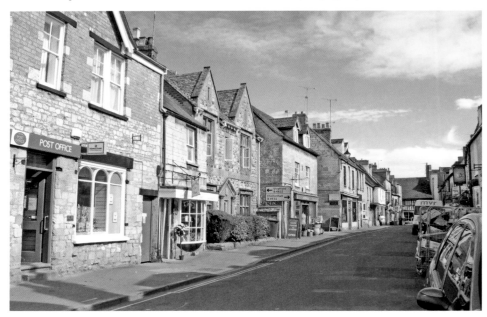

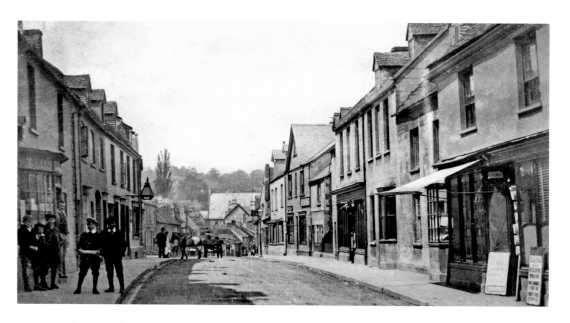

North Street looking away from the Cross

In this view the bow window of the bakery has survived across more than a century. On the opposite side of the street, the nearest shop was Tovey's famous bookshop, which existed for nearly a century after its foundation by George Tovey in 1885. It produced guides, almanacs and postcards, some of which we have used, but the shop is now just one of seventeen branches of one estate agent – a sign of our times? In the distance in both photographs there is a glimpse of the chapel built by Thomas Swinburne of Corndean Hall, using the stone from the silk mill as explained on page 41.

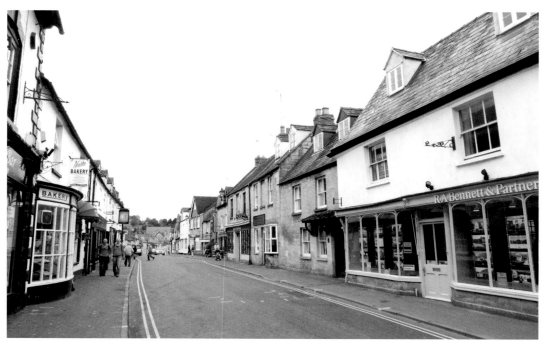

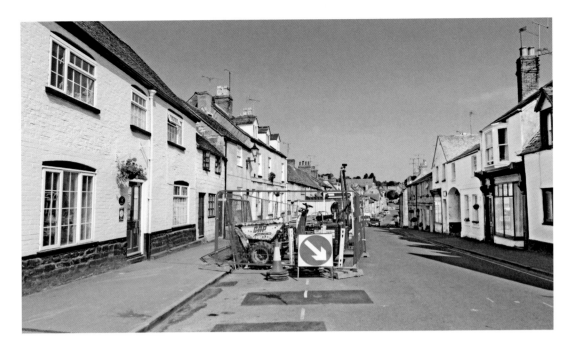

Roadworks!

For residents of Winchcombe and not a few visitors, 2011 will long be remembered for the upheaval caused by the renewal of the gas main through the town. In this photograph taken in July, the work was affecting North Street. Apart from this work, little seems to have changed since the day portrayed in another photograph from the late Harold Greening's collection, except for the appearance of two shop fronts to the right of the picture – and television aerials and motor traffic!

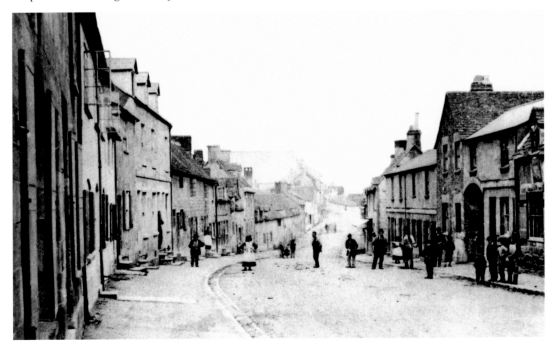

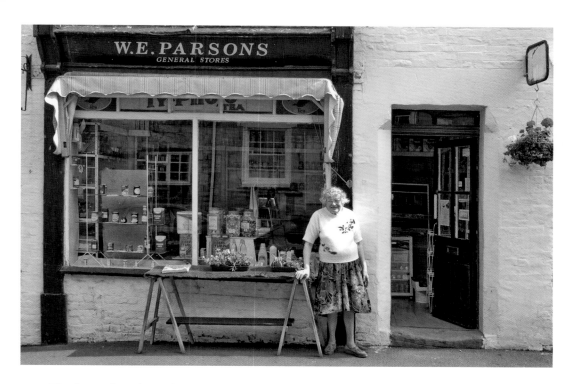

The Pace of Modern Change

Peter Campion's recent photographs of Winchcombe's shops are already archive material! Parsons' shop, seen immediately the other side of the archway in the photograph opposite, was Winchcombe's last remaining small family general store. Now, on the other side of the road, the Co-op serves people's needs, bringing its corporate identity into the town. Yet, as the inset photograph shows, this has already changed remarkably since Peter's photograph was taken in 2008.

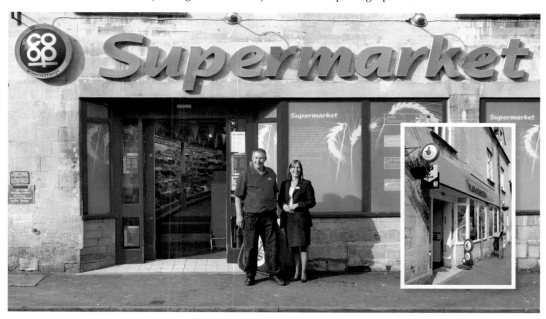

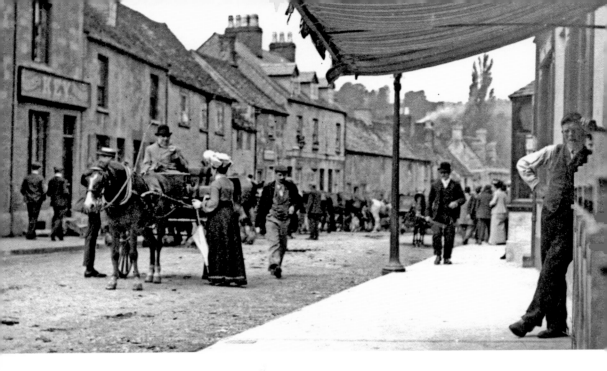

Fairs in North Street I

Horse fairs were a feature of Winchcombe life from at least the end of the twelfth century until the early twentieth century, when they were killed off by the rise of motor transport. They took place on the last Saturday in March and on 28 July, the latter being the main one. John Oakey tells us that in his youth the tethered horses filled the whole of North Street and stretched along Back Lane, Greet and Gretton Roads. At the time of this photograph, Key's the plumber and builder was being run by Miss Julia – an early example of equality of opportunity in the workplace! The business was in existence from before 1868 to the mid-1920s.

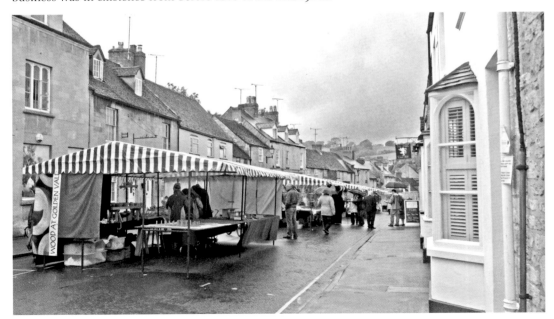

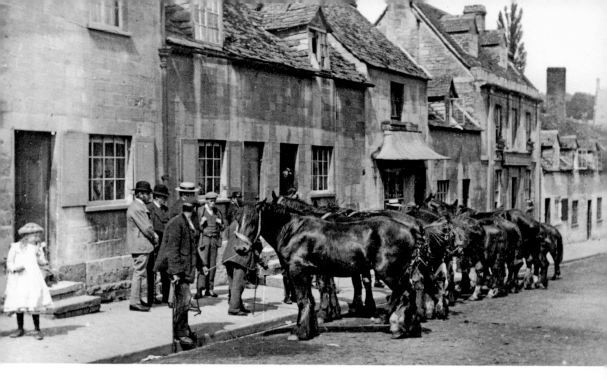

Fairs in North Street II

These two photographs of the horse fair, taken in the early 1900s, show it in decline. The horses are no longer allowed on the pavements which had recently been remade and the buzz and business of previous years is missing. The modern photographs capture a modern fair in North Street – the street market held on the very wet late May Bank Holiday Monday to close Winchcombe's 2011 festival of music and arts. This first festival was so successful, attracting over 3,000 visitors, that it is set to become another addition to the town's annual calendar.

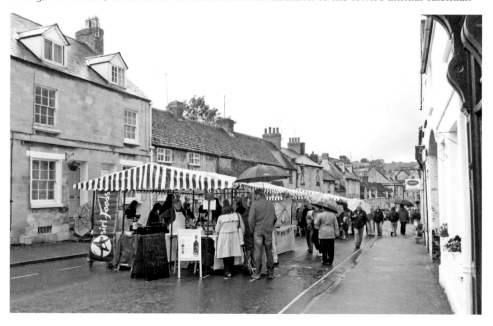

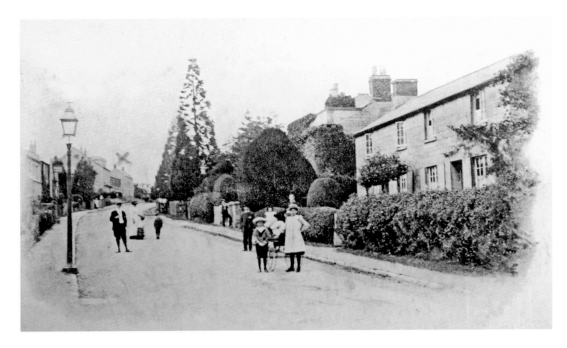

Gretton Road looking West

When Harriett sent this postcard to Francis at a Blackpool address in August 1905, she had obviously patronised George Tovey's bookshop to purchase one of his distinctive cards of local views. Inevitably, the X marked the spot where she was staying. In 1856 the *Tewkesbury Weekly Record* reported, 'At the north side of the town quite a suburb of nice, new, comfortable-looking cottages are in the course of erection' and some of the houses here must date to that period. The modern scene shows it is still possible to take time to pause and chat by the roadside.

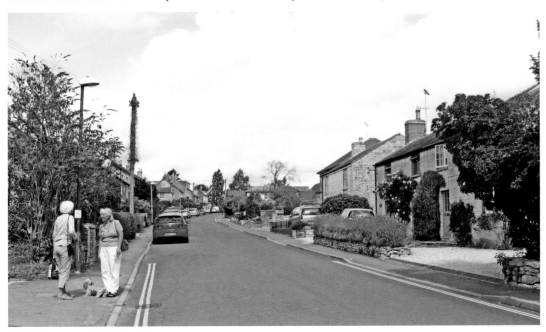

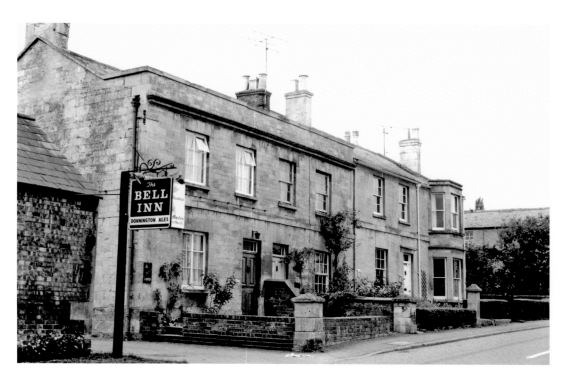

The Bell Inn

Here is another of Winchcombe's lost public houses. The original Bell Inn stood where Dent's almshouses now stand in Abbey Terrace (see page 37). It migrated with its owner Richard Mason to this site in 1863 among the new developments along Gretton Road. The Bell remained in business another hundred and forty years, since when the building with its yard has been developed for housing. However, the name still lives on in the left hand cottage in the modern photograph.

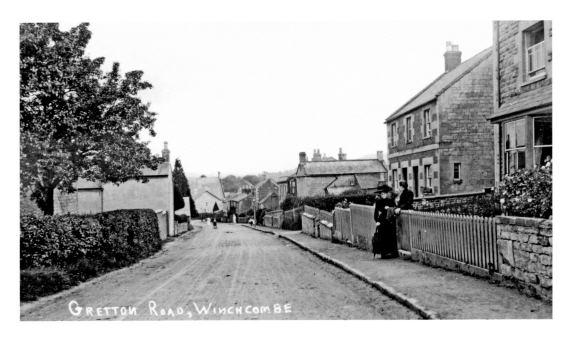

Gretton Road looking East

Little has changed in the hundred years between these two scenes looking back towards the town centre, except for the appearance of cars and poles. Here is another picture of some of those 'comfortable-looking cottages'. One of the ladies has just noticed the photographer, who obviously had trouble with his letters!

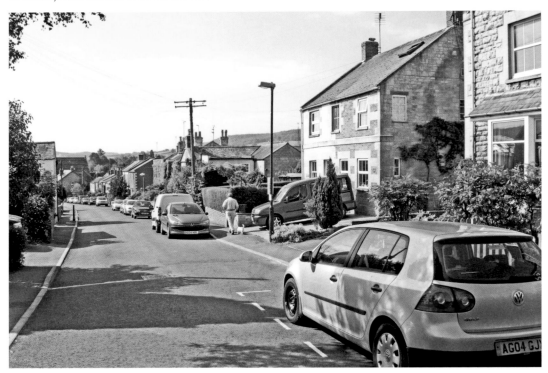

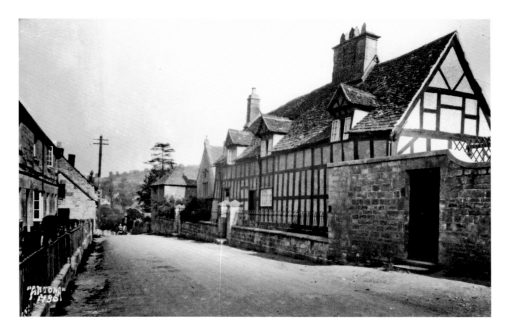

The Presbytery

The demolition in 1954 of this large timber-framed building, which stood in Chandos Street, meant Winchcombe lost one of its finest historic buildings. It was opened in 1621 as the Chandos Grammar School and when the school merged with the King's School in 1876, it became vacant, because a new school was built next to it. After this school closed, it was converted into the Roman Catholic church in 1915 and the original timber building became the priest's residence. Modern economics dictated its demolition and its site is now a garden. The white doorway provides a point of reference.

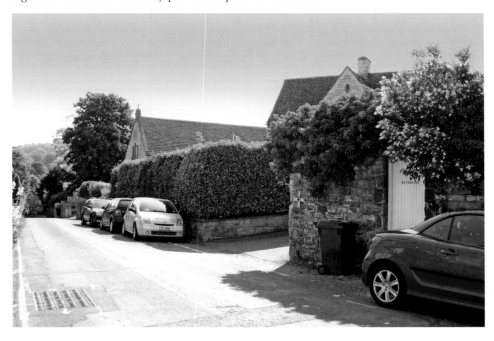

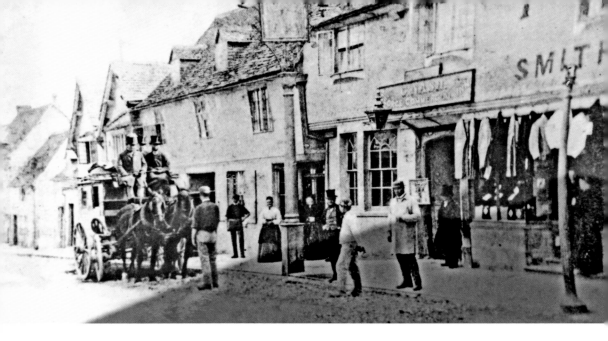

The George Inn I

The George Inn was Winchcombe's premier inn for nearly five hundred years. Occupying a key position by the cross, it was created as a hostelry for pilgrims by the last but one abbot, Richard Kidderminster, in the early sixteenth century. On its sale for redevelopment in 1988, the Hereford Archaeological Unit discovered a cottage dating from 1400 still surviving behind the shop front on the right. The top picture dates from the 1870s and shows Mr Edward Stevens' coach which ran between Broadway and Cheltenham twice a week and changed horses at the George. The lower picture shows the parlour which changed little in the last hundred years of its existence.

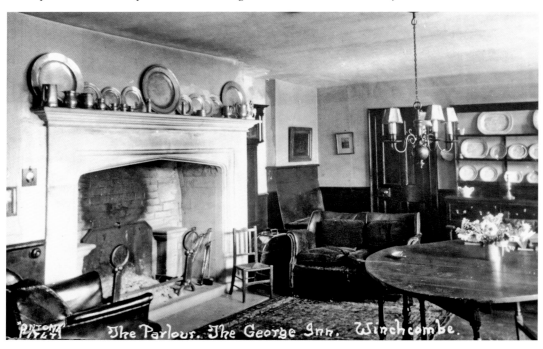

The Parlour. The George Inn. Winchcombe.

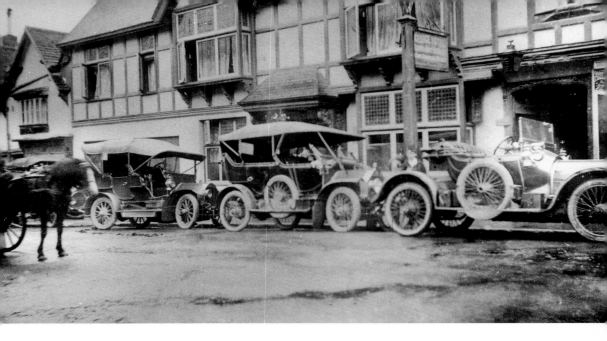

The George Inn II

The George underwent a variety of changes during its long life. The frontage shown on this page was the result of Emma Dent's 'improvements' made *c.* 1884 in an attempt to recreate its medieval appearance. David Donaldson tells us how the hotel enjoyed its own private supply of electricity before 1928; early electric lighting can be seen in the picture of the parlour opposite. The visitors' cars parked in a row, some time before the Great War, would have had a traffic warden reaching for his pencil!

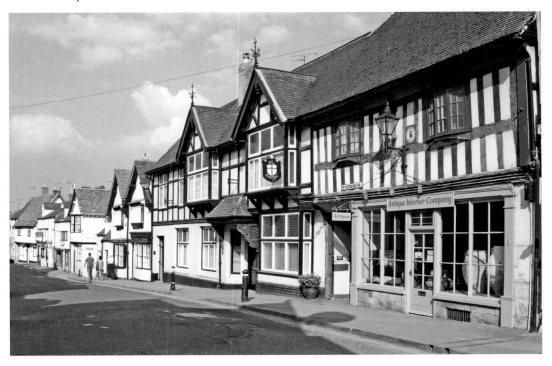

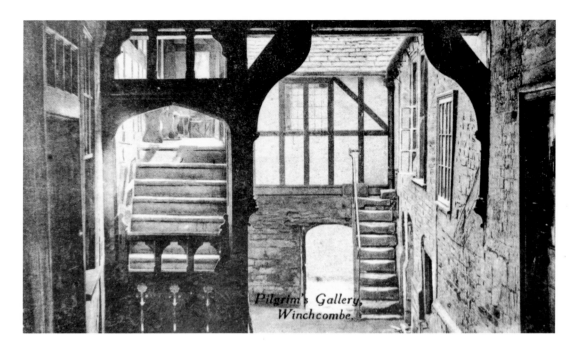

The Pilgrim's Gallery

The wooden doorway shown in the previous photographs is framed by Richard Kidderminster's initials. Beyond the doorway stands this gallery, rebuilt by Emma Dent in 1884 at a cost of £76 and largely unchanged since then, despite the conversion of the hotel into residential accommodation after 1988. It is thought pilgrims to Hailes Abbey as well as to Winchcombe's abbey stayed here in the Middle Ages.

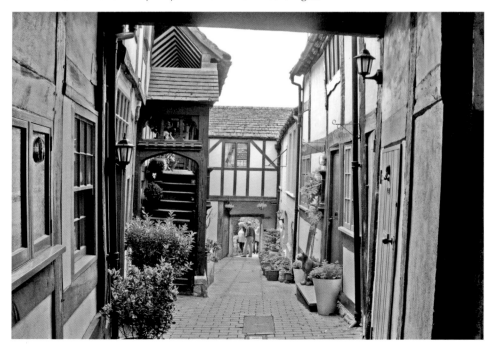

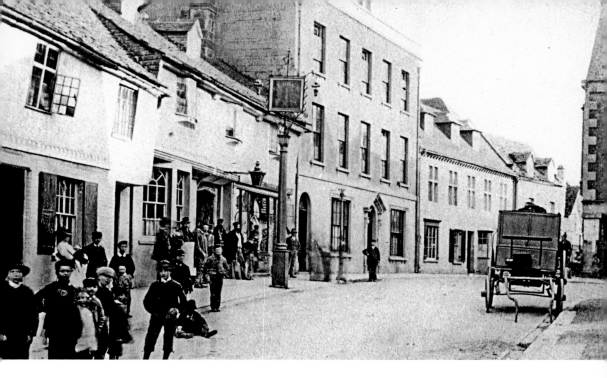

The Cross from the North

These two photographs summarise some of our recent pages with the archive photograph dating before the re-fronting of the George. Next to it stands Lloyds pharmacy. The clock was added to the Town Hall in 1897. In 1999 nearly £150,000 was spent on the Town Hall; £65,000 being provided by the Heritage Lottery Fund – another sign of Winchcombe in the modern age.

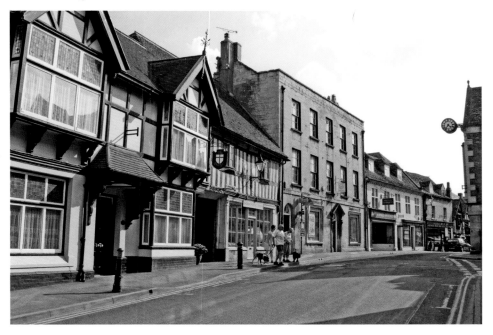

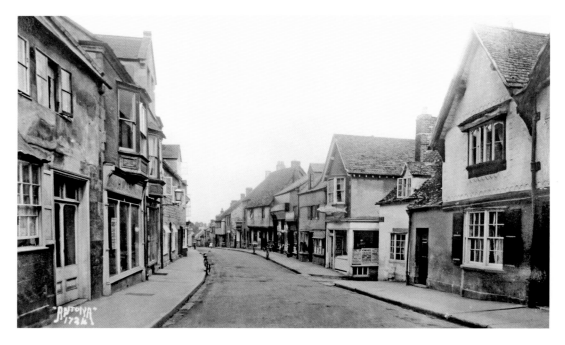

Hailes Street

At the cross the High Street is continued as Hailes Street by which pilgrims to the abbey there left the town to reach Hailes by way of Puck Pit Lane. The building on the left has been stripped of its rendering to show the timber frame beneath, but there is very little change in the ninety or so years separating the two views and timber-framing still abounds in this part of the town. In the earlier view a lone bicycle is leant on the kerbstone; in the modern view a lone pedestrian walks past the same spot.

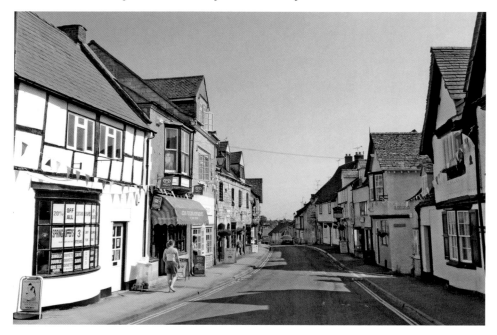

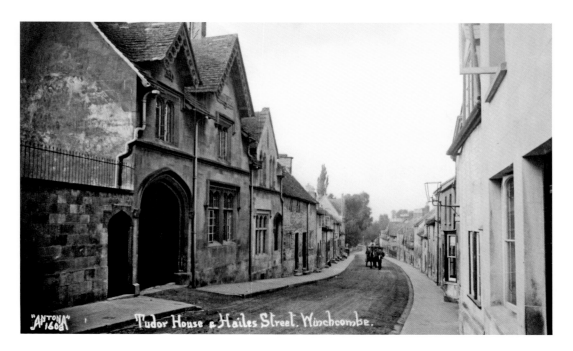

Tudor House

Once a short-lived public house called the Plough, Tudor House is a classic Victorian tudor-style house, built in the 1880s. Again, there has been little recent change in this stretch of Hailes Street, although the black and white timbering has appeared since the earlier view and a car has replaced the horse and cart.

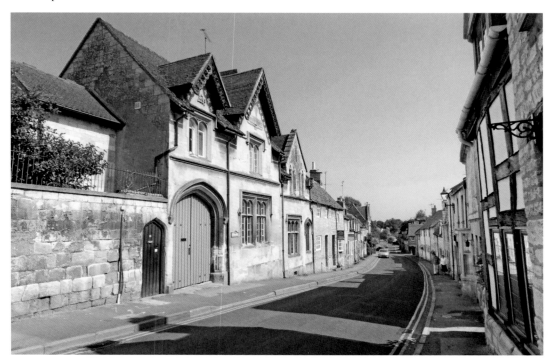

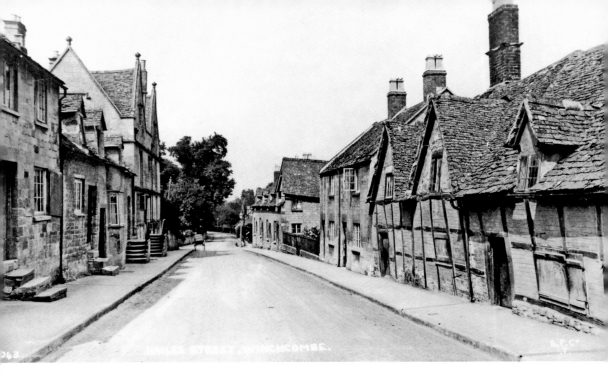

Lower Hailes Street

These pictures continue our theme of little change in Hailes Street. In his *Reminiscences* John Oakey makes quite frequent reference to the demolition of older timber-framed buildings. Here we have an example on the right of the view: houses that have been replaced by buildings which themselves now look historic.

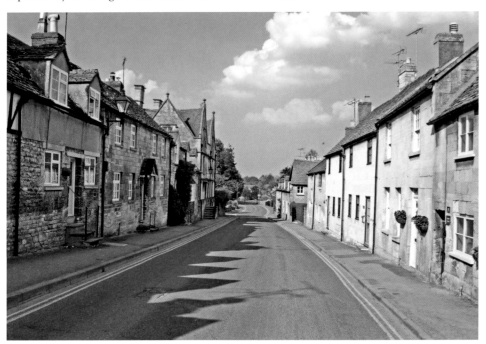

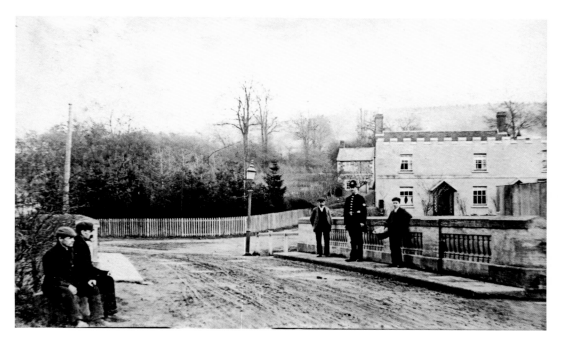

Footbridge

Pilgrims travelling to Hailes Abbey were able to cross the River Isbourne here by a footbridge only after 1531; before then they had to ford the river. The postcard was posted in August 1907 and carried a message that floods were up two feet above the road in the previous week. In 1984 the road and bridge were re-aligned so that the house in the earlier view is now lost from sight behind the trees on the left.

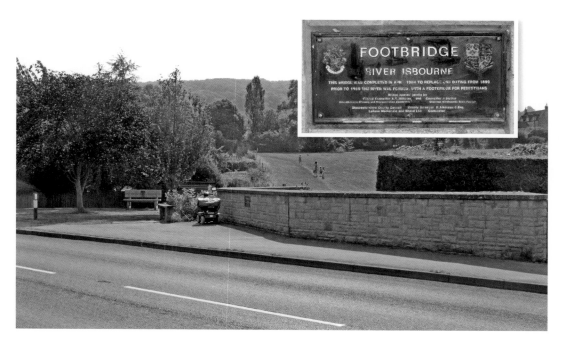

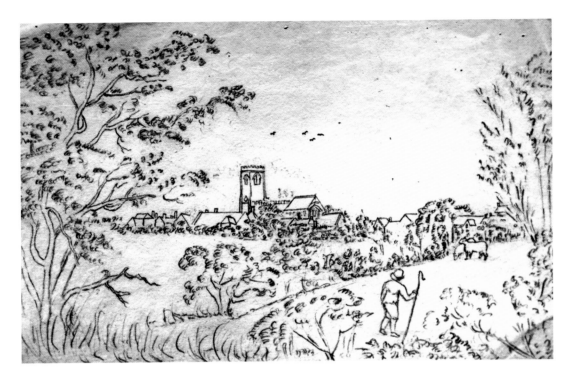

'Winchcombe from Babesmoor'

This delightful pencil sketch, another by Edmund Browne, portrays a rural scene complete with shepherd and sheep. In the distance Winchcombe is indicated by the roofs of the buildings and the old chancel roof of St Peter's before the restoration of 1872. Changes to trees and bushes have unfortunately made it impossible to identify the exact spot from where Edmund drew his sketch. In this modern view from Stancombe Lane, the development behind the George is visible below a glimpse of St Peter's tower.

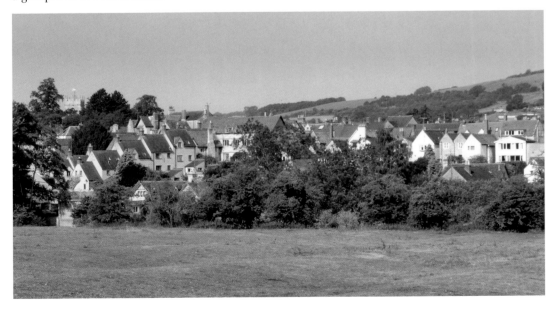

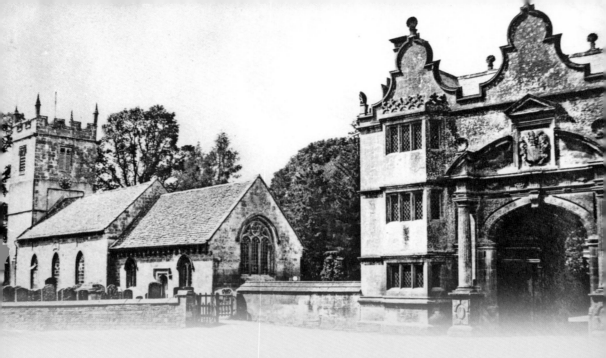

CHAPTER 2

Around Winchcombe

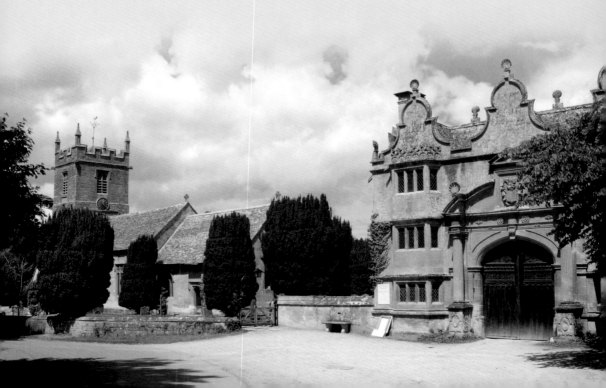

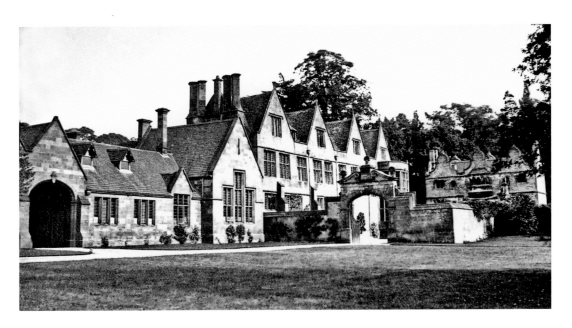

Stanway House I

We start our views around Winchcombe in the north with Stanway House and its estate. Superficially they have changed little over the century and a half which separates our archive from the modern photographs. When the earliest photographs were taken, Stanway was the English home of the 10th Earl of Wemyss and March; it is now the home of the 13th Earl. When the censuses of the mid-nineteenth century were taken, the Earl was absent and only a skeleton staff of three servants was in residence. Today, the servants have gone and the once-private residence now opens its doors to visitors and local events.

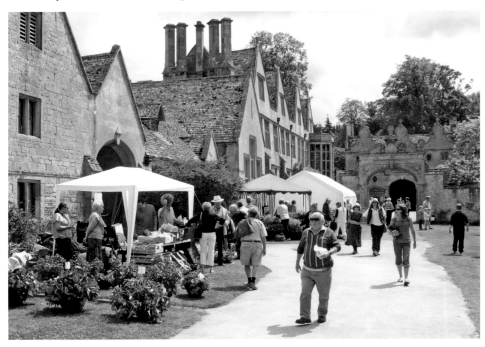

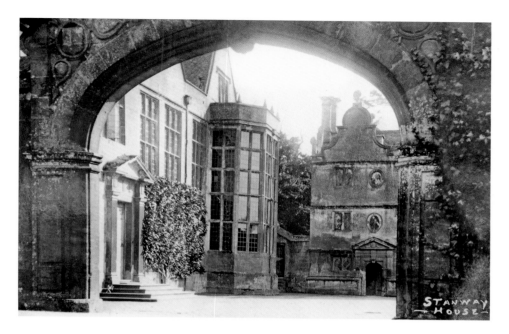

Stanway House II

Our modern photographs capture the annual Stanway village fête held in July. On this page there is an imposing line up of vintage Austin cars stretching as far as the famous oriel window. Other visitors come to visit the unique fountain or to celebrate a wedding; all providing welcome income to enable the house and estate to survive in an age very different from that of a century and a half ago.

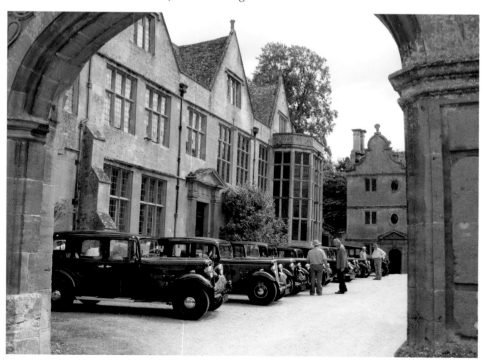

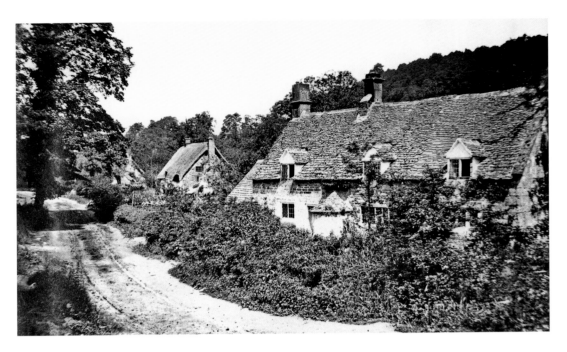

Buckland

The farthest north of the Stanway estate photographs of the mid-nineteenth century shows this scene of cottages in Buckland. The 1851 census counted eighty-seven households in the parish; fifty-two of theme were the households of agricultural labourers and ten were those of farmers. There was then little alternative employment to farming and its related crafts and trades, but fifteen glovemakers were recorded and also three silk throwsters, presumably employed at the silk mill in Winchcombe.

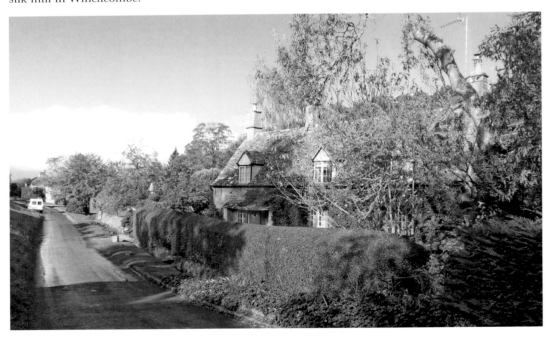

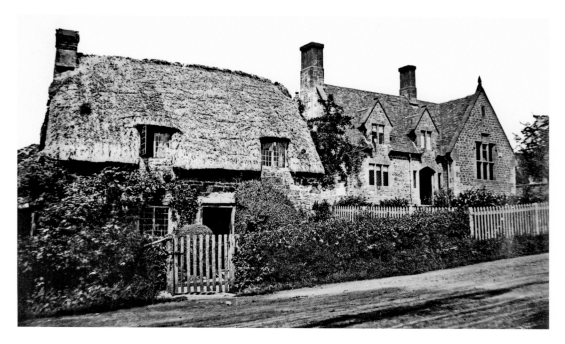

Stanway School

Here is Stanway School, photographed *c.* 1855. The house in the foreground of the upper view was demolished before 1865 and the site has since been reclaimed by nature. In 1881, the schoolmistress was twenty-four-year-old Isabella Smith, who lived there with her older sister Mary. The school was closed in 1928 when it amalgamated with Didbrook School and it is now a private house. In the lower view two cyclists, typifying our modern age of leisure, are preparing themselves for the long drag up Stanway Hill to Stump's Cross.

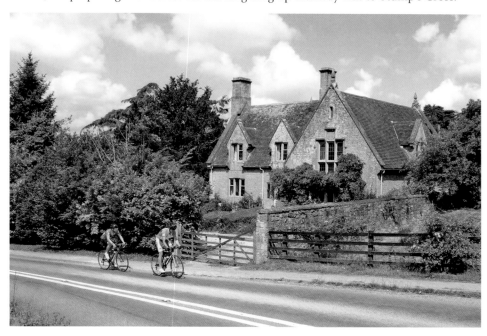

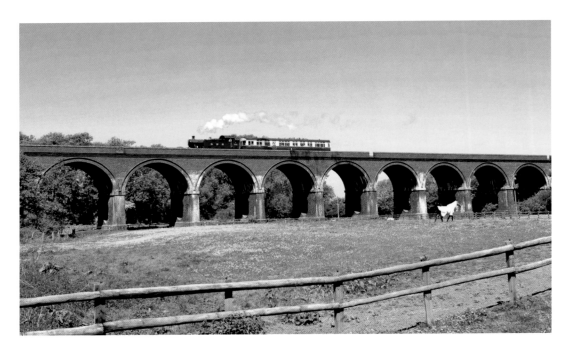

Stanway Viaduct

The year 2011 has been a memorable one for the Gloucestershire and Warwickshire Railway. From April passenger trains have been timetabled over the impressive viaduct in Stanway Grounds for the first time since 1968. During the construction of the viaduct, the central arches gave way and four workmen lost their lives in November 1903. The scale of the disaster is clearly shown in the lower photograph.

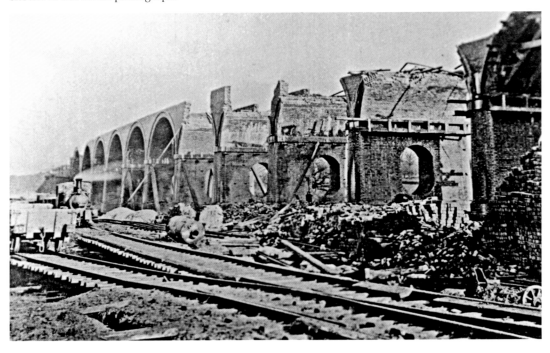

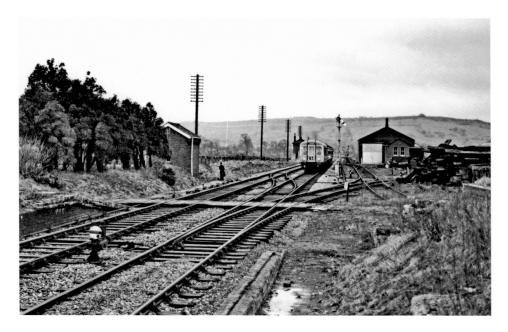

The Railway at Toddington

The headquarters of the heritage steam railway lie at Toddington. In the fading light of a dull March afternoon in 1968, the last-ever scheduled passenger train along the line, from Gloucester to Leamington Spa, heads north past Toddington, watched by a lone photographer. The modern scene evidences the great efforts to rebuild the railway since 1981, for only the signal box and goods shed survive from the earlier scene. This photograph was taken at the very successful gala held in July 2011.

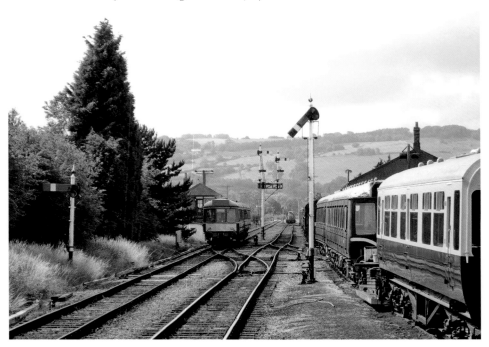

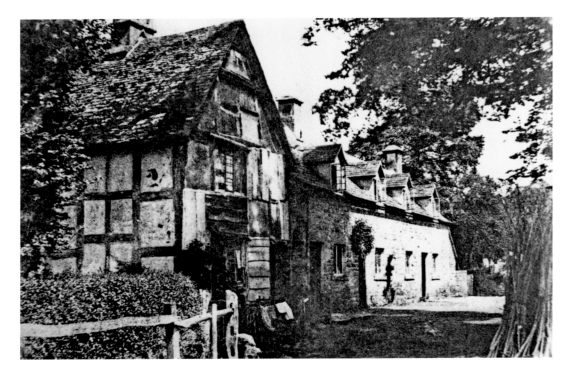

Wood Stanway

This small settlement stands on the Stanway estate and we include another example from the collection of photographs taken to record the estate properties, *c.* 1855. Here the timber-framed wing of the building has been clad with local stone and brick, which was carried out sometime before the last war.

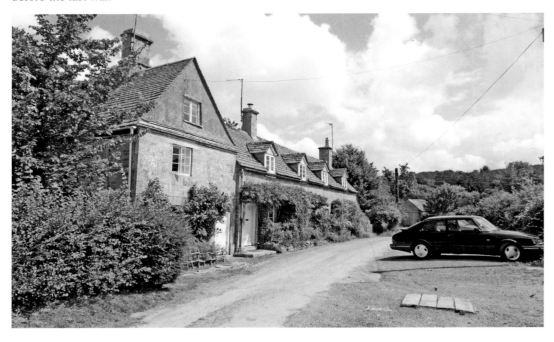

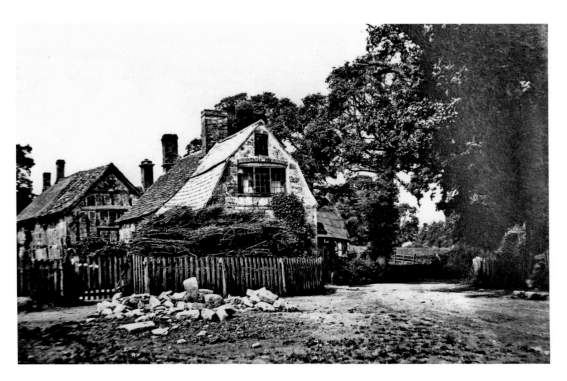

Didbrook

These photographs are full of interest. The large building in the centre of the mid-nineteenth-century photograph was demolished before 1896, when the village was acquired by the Stanway estate. The building to the rear served as a school about the time of the earlier picture, before it later became a forge. The inset shows Mike Hamlett at work there in April 1975.

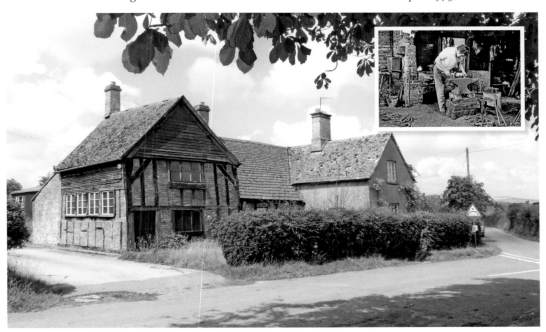

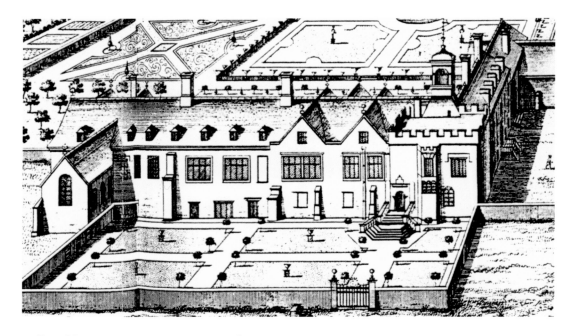

Hailes Abbey: From Manor House to Ruin

Hailes Abbey lies three miles to the north east of Winchcombe. Founded in 1251, it became famous for possessing a glass phial, said to contain Christ's blood from the cross. The abbey was dissolved on Christmas Day 1539. The local Tracy family then converted the former abbot's house into a country mansion before they moved to Toddington. The engraving shows this house in *c.* 1700 before its decline into the ruin sketched by Edmund Browne a century later. The top of the three remaining arches can just be made out in his sketch.

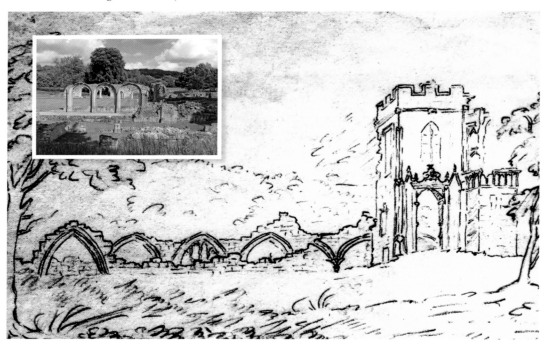

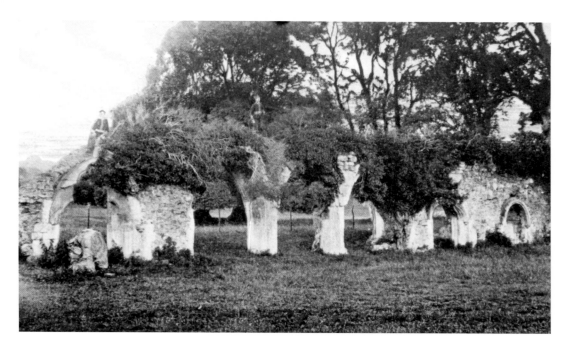

Hailes from Ruin to Ancient Monument I

This heavily tinted postcard was posted in 1917, but the red tunics of the daring young men who can be seen emerging above the ivy-clad walls suggest a photograph of a somewhat earlier date. The site which visitors see today is largely the result of extensive excavations which were undertaken between 1889 and 1908, when many thousands of tons of soil, which had been laid across the site to make the formal gardens of the Tracys' manor house, were removed.

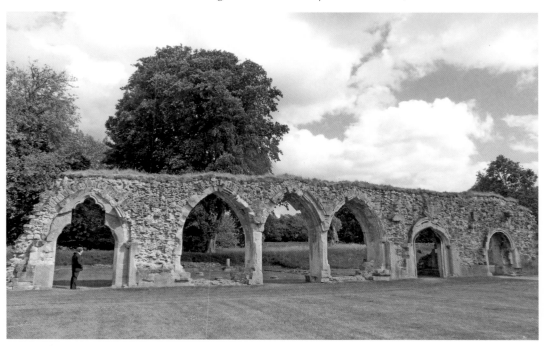

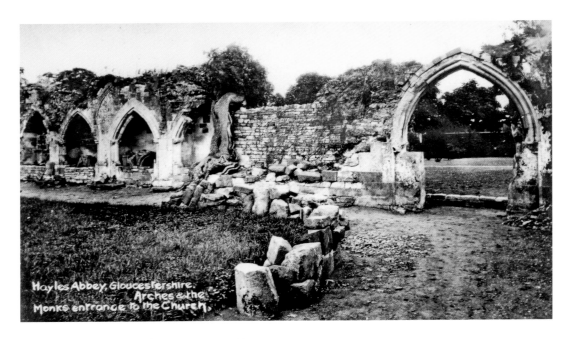

Hayles Abbey, Gloucestershire. Arches & the Monks entrance to the Church.

Hailes from Ruin to Ancient Monument II

Serious attempts to clear the remaining walls of ivy and protect their condition began in 1927. A small museum was opened and the Great Western Railway was persuaded to build a halt at the nearby road bridge to make it easier for visitors to travel to the site. The site was handed to the National Trust in 1937 and since 1948 it has been managed by what is now English Heritage. It still attracts many people today seeking its solitude and quiet atmosphere.

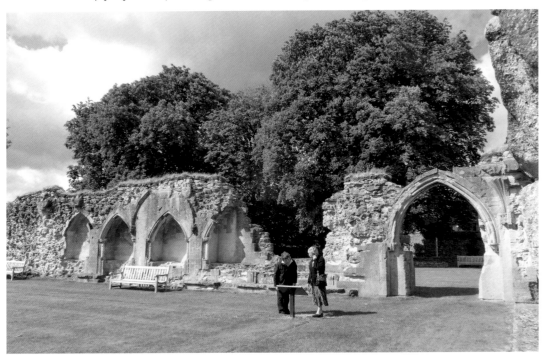

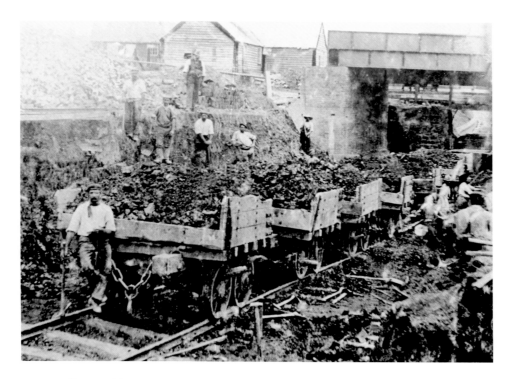

Greet Railway Bridge

The upper photograph records the navvies building the railway track under the bridge by Winchcombe station in Greet in 1905. In the background can be seen the huts in which they lived. The lower picture captures a Stanier heavy goods locomotive running under the same bridge during this summer. It had been sent to Turkey in 1941 as part of the war effort and was brought back to England in 1989 and restored to use. During 2011 four members of the railway society brought back two more similar locomotives in an epic adventure which appeared on television in the series *Monster Moves* on Channel 5.

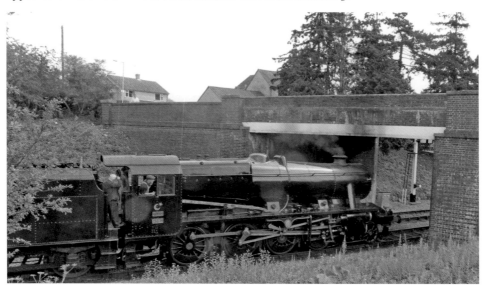

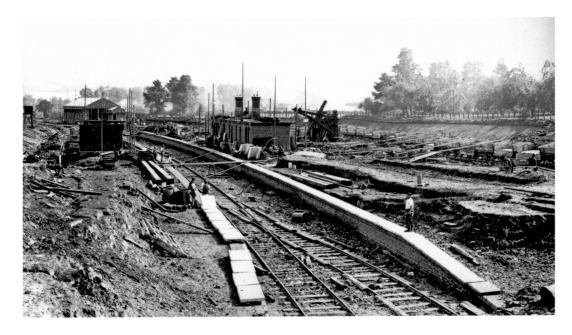

Winchcombe Station

The upper photograph shows the station under construction in 1904. This served the area until passenger trains between Cheltenham and Honeybourne were withdrawn in March 1960. The lower photograph shows the present station, opened in 1987 by rebuilding a disused station building from Monmouth the previous year. The signal box came from Hall Green near Birmingham and the platform edging came from Birmingham Snow Hill and Cheltenham St James stations. John Oakey regretted the original building of the line in what had been 'a deep wooded dingle'.

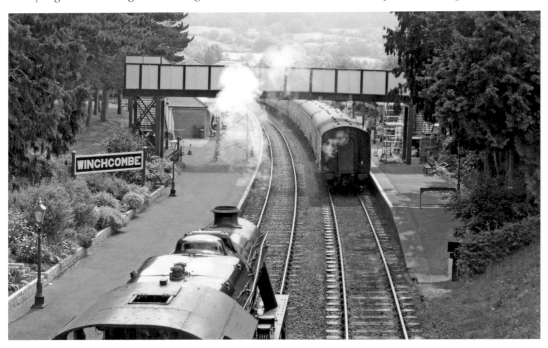

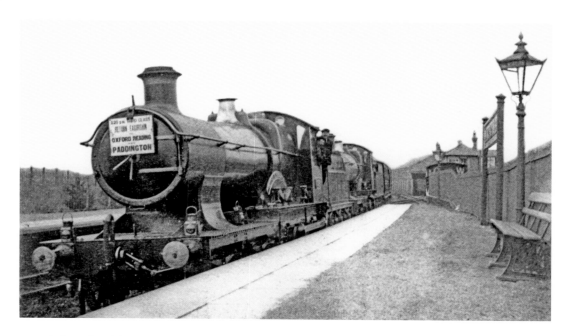

'Albany' and 'Foremarke Hall'

These two scenes have been taken from almost the identical spot. 'Albany' is returning from Paddington with an excursion. We know it must be some time after 1912 as in that year the locomotive was given the number 3394, eight years after it had been built. 'Foremarke Hall' has been hauling passengers on the line since 2004. Built in 1944, it was withdrawn in 1964 and spent the next seventeen years at the famous Barry scrapyard before being restored by enthusiasts of the Swindon to Cricklade Railway. Its pristine condition now makes it a major attraction on the steam railway.

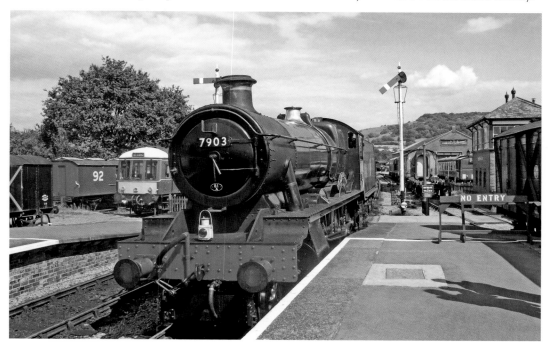

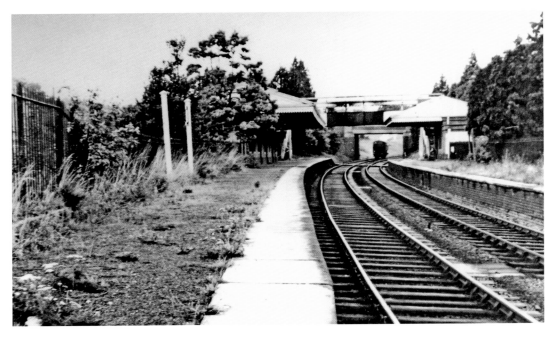

Fall and Rise I

Winchcombe station presents a forlorn appearance with its grass-grown platforms and missing name boards shortly before demolition in 1964. In the distance a light engine can be seen passing through. The modern scene is very different with well-maintained buildings and platform furniture to greet the many passengers awaiting the arrival of a train from Cheltenham Racecourse station.

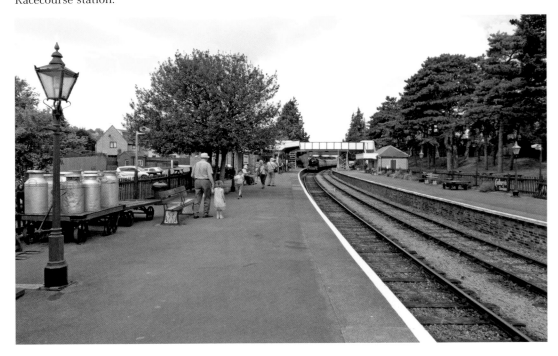

Fall and Rise II

A second reason that 2011 has been memorable for the GWR is because the line was closed north of Winchcombe as the result of a collapsing embankment and so the train services have had to operate in two parts. The landslip was just to the north of the location of these two scenes. The upper shows how the former goods yard became the centre for the dismantling of the line, which was taking place in 1979 when the photograph was taken. Contrast this with the lower scene showing the locomotive about to run around its train to take it back to Gotherington and Cheltenham, watched by a number of summer holidaymakers. The distant hills provide a point of reference for the two photographs.

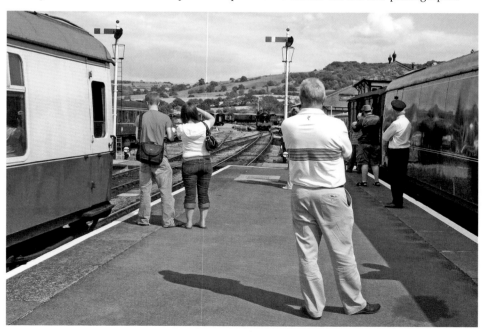

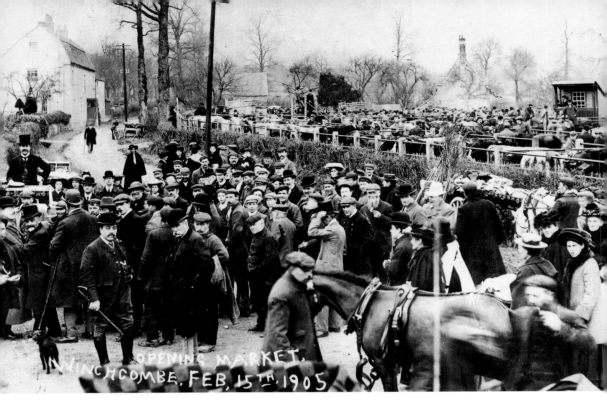

OPENING MARKET.
WINCHCOMBE. FEB. 15TH 1905

Greet Market

One consequence of the opening of Winchcombe's railway station was the establishing of a market immediately to the west of the station. Although very popular on its opening day, just a fortnight after Winchcombe station itself had opened, it was destined to continue for only twenty years, suffering from the competition from Andoversford and Gloucester markets. The site is now occupied by a row of bungalows; only the Harvest Home public house serves as a reminder of the changes the arrival of the railway brought to Greet.

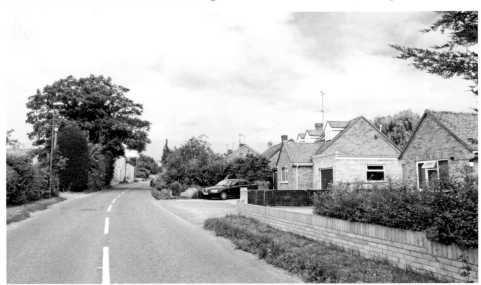

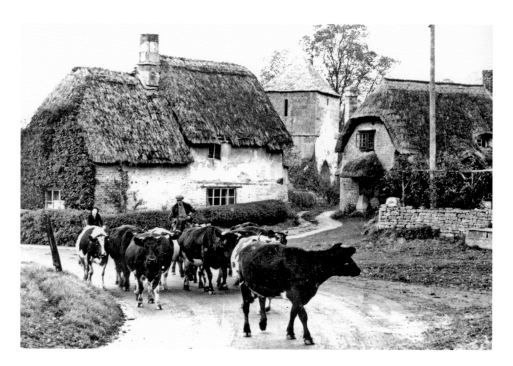

Gretton Village

Traditionally referred to as 'Cow Muck Corner' by older local people, in this scene in the village centre, farmer William Townsend rides his pony to drive his cattle to Gretton Farm, *c.* 1940. Just visible between the cottages is the tower of Gretton's medieval church, which was replaced by Christchurch in 1868. A slightly changed perspective and encroaching greenery now obscure its view.

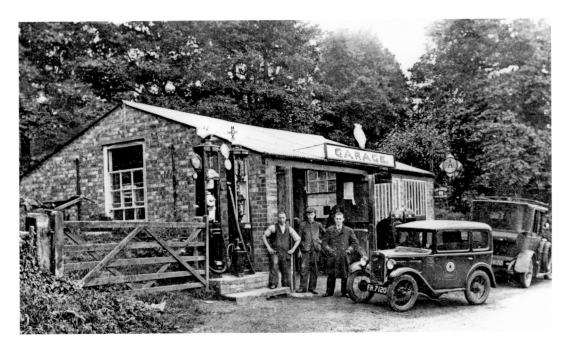

Gretton Garage

The garage was started by the village schoolmaster Conrad New in 1912. His three mechanics, Len Green, Bob Theyer and Ernie Davis pause for the photographer some twenty or so years later beside an Austin 7 and a French Berliet taxi. In his book on the history of the garage, Peter Campion tells us this was Con's second garage, built *c.* 1919–20; his first was a converted cottage. By the new millennium the garage became dilapidated and was demolished. In the roof apex of the replacement house a stone inscription reads 'Gretton Garage' to commemorate the vanished business.

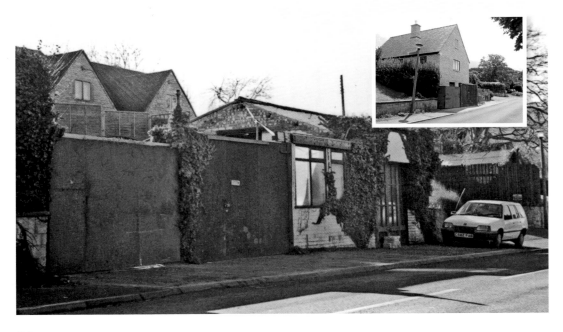

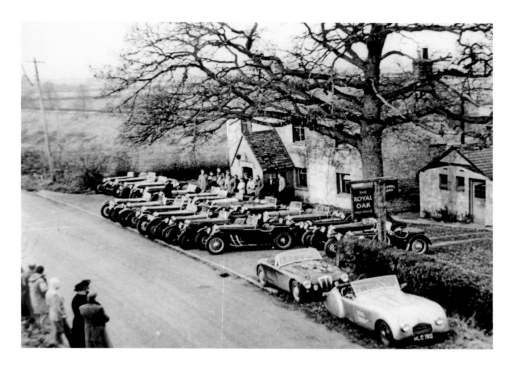

The Royal Oak

One of two public houses in Gretton, it stands as a backdrop to a large number of rare Frazer-Nash cars in a photograph from the early 1950s. We presume they were connected with the world-famous Prescott Speed Hill Climb of the Bugatti Owners' club, which lies barely two miles away. Today, the road is wider and such a gathering would be impractical in the space now available in front of the entrance porch.

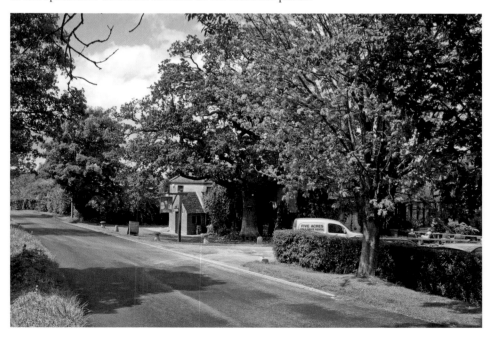

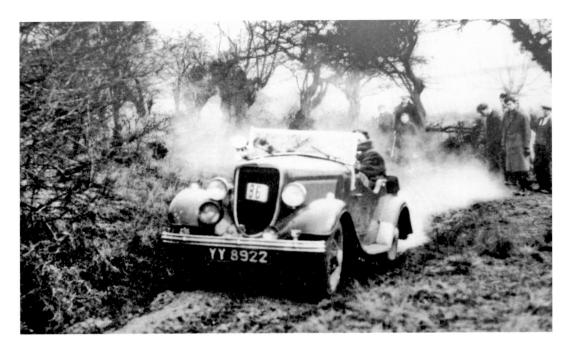

Gypsy Lane

This rough track leads from the Gretton to Winchcombe road up the steep northern slopes of Gretton Hill. In 1934 it was chosen as a special stage in the famous Colmore Cup motor trials based in Birmingham, when an incredible 155 cars were driven along it. Here Lord Avebury makes the ascent in his 1932 Ford on a cold day in February. It's almost impossible to imagine that event taking place at this tranquil corner of a country bridle path high above the vale.

Waterhatch I

Our journeying around Winchcombe now takes us from north-west to south-east and the track leading to Spoonley Farm, where this decaying petrol pump stands on the verge, close by a variety of isolated farm buildings. The lower photograph shows it has not always been like this, for the pump was one of two serving Waterhatch Farm and is seen with a now-lost twin at a meeting of the hunt in the mid-1950s. The Cotswold stone farm building has also disappeared, replaced by a functional prefabricated barn.

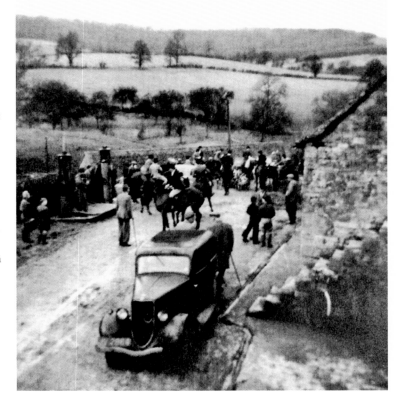

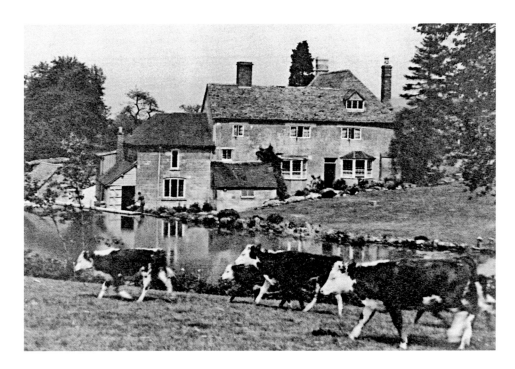

Waterhatch II

Through the bushes in the previous photograph lies a secret place, the remains of a traditional Cotswold farmhouse, which stood on the Beesmoor Brook as it runs down from Spoonley into the River Isbourne in the valley. The Sudeley estate map of 1848 shows a farm with its outbuildings and three millponds. In 1945 the Corfield family moved in and used the water to drive a waterwheel to generate electricity for use on the farm. Today, only the concrete retaining wall survives to link the two photographs taken only half a century apart.

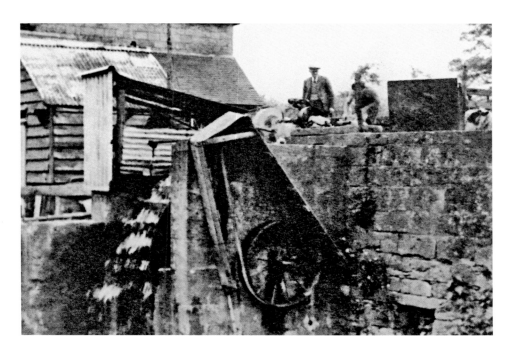

Waterhatch III

These photographs show a close up of the wheel site, just seen to the left of the farmhouse on the opposite page. In the upper photograph it is being used to generate electricity for shearing the sheep. The Corfields moved out in 1956 and for five years the Slade family continued to run the farm until subsidence meant they had to leave. In the last half century nature has largely reclaimed the site; the house has gone, the waterwheel housing and pig sties are crumbling away. Fortunately, the museum in the Town Hall has an excellent archive for readers who are fascinated by these mysterious remains.

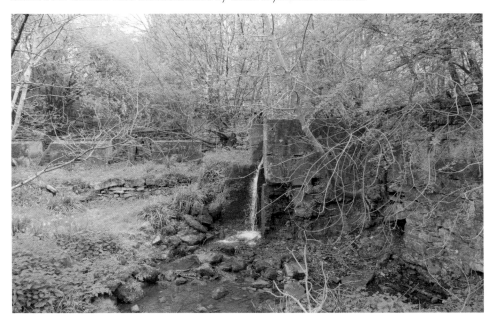

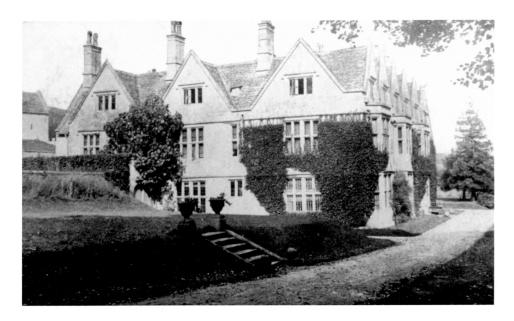

Postlip Hall

The hall dates mostly from the early seventeenth century. When this postcard was sent in 1905, it was the home of Mrs Elizabeth Foster, a staunch Roman Catholic (she refused to sell the hall to a Protestant!), who restored Postlip chapel and financed the changes to the church in Winchcombe. After her death in 1915, the hall passed though different hands until it was bought by a housing association in 1970 and divided into eight self-contained units. Every year in the summer the association organises a very popular beer festival, seen in the two modern photographs, for their communal funds.

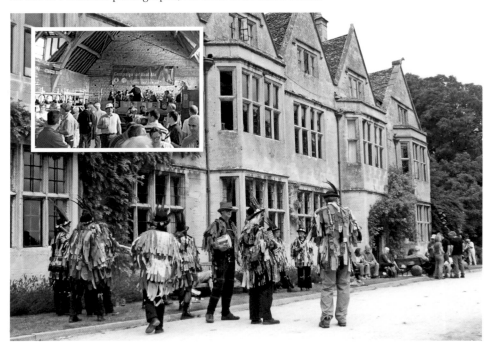

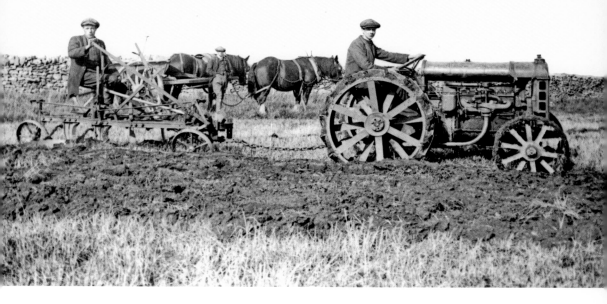

Corndean Hill Barn Farm

High above Winchcombe to the south, a very young Harold Greening poses for the photographer on a new Fordson tractor in August 1918. The Great War stimulated a new order of mechanisation in agriculture but horse teams were still working the land. Today the change is complete; the tractor is the reigning power whilst a horse grazes peacefully in the background.

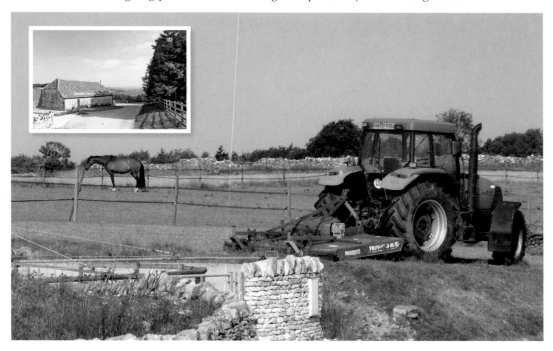

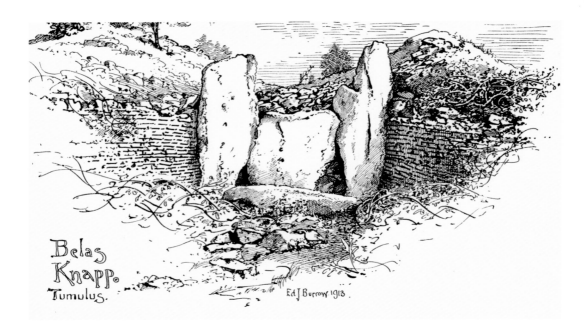

Belas Knap

How many walkers along the Cotswold Way realise that what they see at Belas Knap is largely a construction made after excavations in 1928–30? The evidence for this can be seen from the sketch of 1913. The stones in the centre represent a burial place of *c*. 3500BC, but the other burial chambers beyond it were in use from *c*. 3000BC to 2500BC and contained the remains of thirty-eight people. Archaeologists still remain unsure about the significance of such long barrows, many of which lie dotted across the Cotswolds.

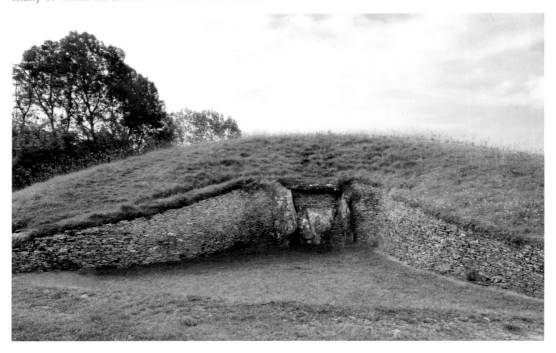